NATIONAL GEOGRAPHIC
PHOTOGRAPHY
FIELD GUIDE
TRAVEL

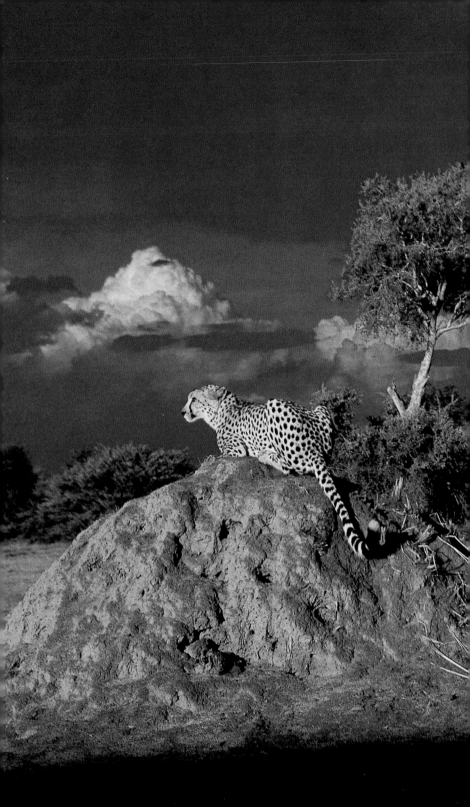

NATIONAL GEOGRAPHIC
PHOTOGRAPHY
FIELD GUIDE
TRAVEL

SECRETS TO MAKING GREAT PICTURES

ROBERT CAPUTO

NATIONAL GEOGRAPHIC

WASHINGTON, D.C.

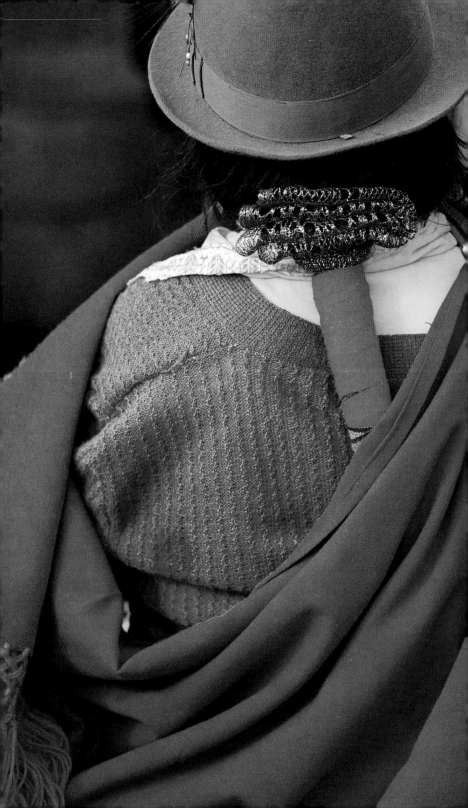

CONTENTS

INTRODUCTION 6

BRINGING BACK A SENSE OF PLACE 8

IRA BLOCK Playful Creativity 26

THE RIGHT STUFF 32

COMPOSITION 50

TECH STUFF 66

SARAH LEEN Engaging the Subject 78

LOCATION LIGHTING 84

WEATHER AND SEASONS 92

104 TIME OF DAY

116 JIM RICHARDSON Being Prepared

122 TRAVEL SUBJECTS

146 EXTREME TRAVEL

150 WHEN YOU GET HOME

156 USEFUL INFORMATION

158 INDEX

160 CREDITS

PAGES 2-3: Late afternoon light lends warmth to cheetahs scouting for prey in the Okavango Delta of Botswana. Think about what light and time of day are appropriate for the subject.
Chris Johns

OPPOSITE PAGE: Colors and shapes can say as much about people as their faces. Look for the unusual subject or angle.
Pablo Corral Vega

WE ALL LOVE TO TRAVEL—some of us to exotic lands far away, others to attractions closer to home. Some people like the comforts of luxurious resorts or cruises, others like to rough it in the wild. Many of us travel to enrich our lives with exposure to nature's majesty or mankind's cultural diversity, others simply to get away and relax. Some of us, at different times in our lives, do all of the above. What we all have in common, no matter how the type of travel or reasons for doing it may vary, is wanting to come home with photographs that capture both the look and feel of the places we visit; photographs we can share with family and friends; photographs that will in later years help us recall those times of our lives.

But good travel photography is not easy. It requires us to be jacks-of-all-trades—we must be able to make good images of all sorts of subjects: landscapes of mountains, prairies, or beaches; cityscapes and street scenes; our family members in all sorts of locations, and the people who live there too. We might photograph wildlife, monuments, amusement park rides, flowers, sports, airplanes—the list is as long as all the world holds and as varied as our interests.

In this book we will explore some of the technical aspects of travel photography—choosing and using the right film and/or digital gear and learning how to take care of it; using and adding to location lighting; getting ideas for shooting in all sorts of circumstances. We will discuss how to

Jonathan Tourtellot

think about your photographs, how to capture the sense of place that you want to bring home. Photography, like any other skill, is mostly about thinking. And we will get tips from three veteran National Geographic photographers who have devoted their lives to showing the rest of us how certain parts of the world look and feel.

As you travel your neighborhood or the world, use this book to nudge along your own creativity. And remember that you can't get good pictures from your hotel room. In photography as in life, get out there and explore.

Keep your eyes open and camera ready as you head out into the world. Architecture, colors, the dry mountains behind, and even the cobblestones in the street give us a sense of this town in Mexico.

EACH PLACE WE VISIT has its own particular look, character, and ambiance. If we want photographs of our travels to be good and lasting, they should capture all of these qualities, and say as much about a place as give the literal look of it. We are unlikely to long remember the smell and buzz of a flower garden in spring, the awe of gazing for the first time at the mountain we intend to climb, the caress of a tropical breeze, the thrill of a huge roller coaster, the wonder of our first wild bear, or the adrenaline of rafting white water. Our photographs need to bring these and other sensations back, to trigger our memories, and to communicate how we felt to others. To do this, we need to think and feel as much as look when setting out to make photographs.

First and foremost, think about what made you decide, out of all the places in the world, to choose this particular destination. Whatever it is—the beach, the rides, the mountain, the galleries, the food—obviously appeals to you. If it didn't, you wouldn't be going there. That site or activity (or inactivity) is one of the things you want to photograph, and we will discuss particular travel subjects in Chapter Eight. But there are probably many other interesting aspects of the place you may not be aware of. That's where research comes in.

Photographers for National Geographic spend a lot of time doing research. This helps us figure out what's there—what the place is about and

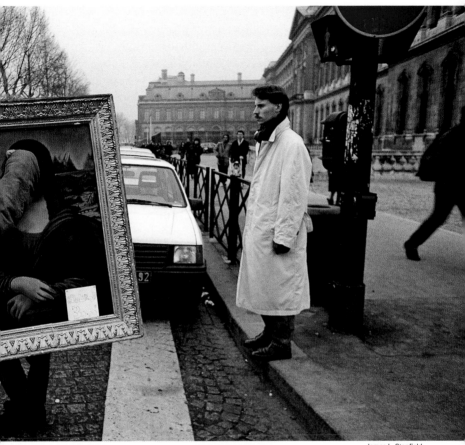

James L. Stanfield

what subjects we need to cover. Read brochures and travel books. Go to libraries, bookstores, or onto the Web. Talk to friends who have been there. Pick up travel information at the country's embassy. Find whatever you can that is relevant, and devour it.

Research generally reveals the more well-known aspects of a place—the monuments, museums, markets, parks, and other attractions that make the place a destination. But don't limit your research to reading. Go to bookstores to browse through photographic books about the

Wherever you go, be on the lookout for humor you can incorporate into your photographs. The arm protruding through Mona Lisa's face arrests our attention. The cobblestone street and buildings give us a feel for Paris.

place. Look at back issues of NATIONAL GEO-GRAPHIC and other magazines. Photographers usually cover more than just the well-known attractions, and the books and magazines will give you ideas of things that lie off the beaten path. They will also show you how others have treated both familiar and unfamiliar subjects. The idea is not to copy what other photographers have done, but to get information that will help you make your own images of the place. You will probably notice that many of the books and

Both the feeling and look of a hilltop town are portrayed in this dramatic image of La Morra, Italy. Notice how the photographer used the sweep of the vineyard in the fore-ground to take our eyes to the town.

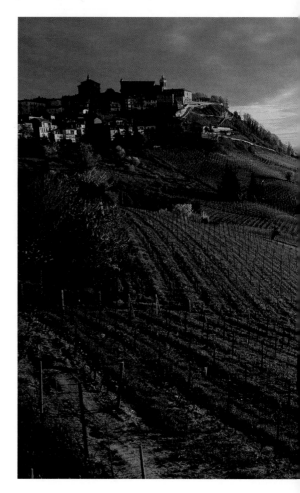

magazine articles have pictures of the same things. A story about Rome would seem deficient without the Colosseum or the Spanish Steps. This doesn't mean that they have to be in every story, of course, but they do tend to show up in most travel stories. But notice how different the pictures of the same thing often are. Professional photographers tend to work extra hard on well-known subjects because, quite frankly, if you can't come up with something different, there's not much point in making the image.

William Albert Allard

Notice how different photographers have shot the subject in different light, in different weather, or from a different angle. Perhaps they've made use of people, trees, or some other secondary subject to give their images a different look and feel. The point is, a picture of any subject should not just be *a* picture of the subject, but *your* picture of the subject. Looking at the work of others should inspire you not to copy, but to take off.

While you're at it, look through other kinds of photographic books as well. Many bookstores are equipped with comfortable chairs and do not mind customers spending time browsing through their books. If you know the place you're going has beautiful mountains, look at books of mountain photography. If your destination is a desert, look at ones of deserts. When you see images that you find particularly appealing, stop and study them. How did the photographer accomplish the effect? What is the light like? What angle did he shoot it from? What kind of lens did she use? Look carefully at the composition and try to decipher how it works. There's nothing wrong with learning from the work of others—painters, musicians, and other artists study the efforts of their forebears and contemporaries. It's how we all learn. The goal is to educate yourself so you can accomplish the main task of the good travel photographer: to show the expected in unexpected ways and to reveal the little-known or unknown.

Thorough research includes getting hold of some of the literature from the country or area you are going to visit. Every culture produces wonderful poetry, fiction and nonfiction prose, and plays, perhaps even movies. If you are going to remote areas to visit people who live in traditional ways, look for books they have written or anthropological ones that describe their culture

Tip

The Internet offers a great way to do research. Search for both information and pictures of the place you're going. Good research helps you save precious time on your trip.

Intricate artwork, poetry, prose, and a passage from the Koran decorate columns in the Friday Mosque in Herat, Afghanistan. Notice how the photographer included a human figure to show us the size of the columns.

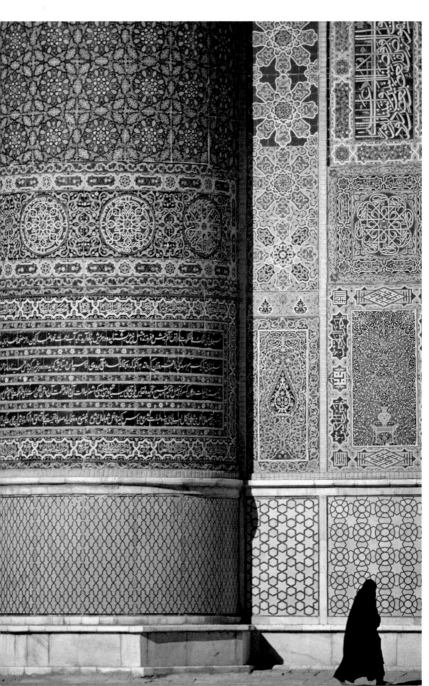

Thomas J. Abercrombie

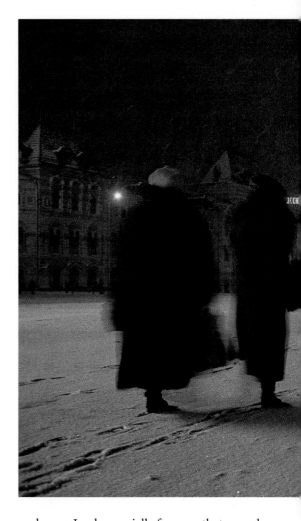

The onion-shaped domes of St. Basil's Cathedral immediately evoke the idea of Moscow in our minds. Using a slow shutter speed while shooting at night, the photographer slightly blurred the women walking across the square, which reinforces the idea of cold.

and ways. Look especially for ones that record oral myths, legends, and history. If you have access to a good library, you may be able to find relevant books there. If you can't, ask the librarian to help you—they usually can borrow books on interlibrary loan. Researching the literature of a place is one of the most enjoyable ways you can spend your time before traveling. It is also at least as valuable as the more mundane "what's where" research. Literature provides you the opportu-

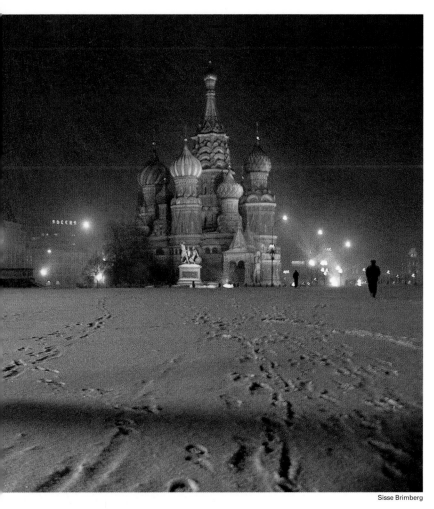

Sisse Brimberg

nity to look into the soul of a place, to see how people from that region or culture look at the world—how they think, what they consider important, how their emotions are stirred, what their customs are and why. It will also provide you with a way to see how people regard themselves and their history, which can often be markedly different from the way we have learned it in school.

Understanding the customs and traditions of

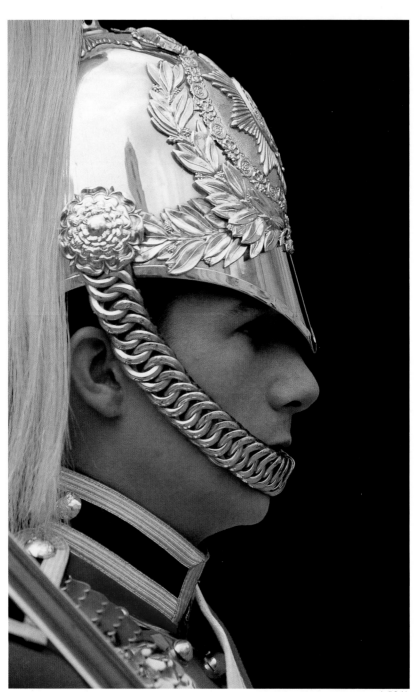

Jodi Cobb

a place is vital. For one thing, you want to be sure you act in a way that is not rude or offensive while you are there, and it's hard to know what's acceptable and what isn't without some knowledge. It can also help you understand things people do that at first encounter you might consider incomprehensible or even horrifying.

For example: I was working in southern Sudan many years ago, with a group of people called the Nuer. I noticed right away that everybody except young children was missing their two lower middle teeth, and wondered why. An elder explained to me that when boys and girls have grown in their adult teeth, an elder pries out the lower middle ones with a knife. He said that this is a mark of the Nuer, that it was a tradition going back as long as anyone could remember, and that it was very bad to be an adult and still have those teeth.

The thought of having teeth pried out with a nonsterile knife—and without any sort of anesthetic, mind you—made me wince. I thought it was a silly and unnecessarily painful practice to put everybody through. Later, after I was back home, I did some more research (which I should have done before going) and discovered that there was a very practical reason for removing the teeth. What I had taken for rather mindless mutilation was actually rooted in survival and, like many customs, evolved over time from necessity into tradition: Tetanus and the resultant lockjaw are endemic worries for the Nuer. Having a hole to get food into someone's mouth can make the difference between life and death.

When you arrive at your destination, be open to and try to take note of first impressions— write them down if you have to. (A notebook is an essential accessory for a travel photographer.) When you see a place for the first time from the

The photographer used a telephoto lens to get this portrait of a guard at Buckingham Palace in London. The clean and dark background makes the helmet really pop out of the frame.

plane window, or when you drive around a bend and there it is, or as the ship nears some distant island—how do you feel? Where do your eyes go first? What do you notice about the place right away? A smell? The heat or cold? Blistering sunlight? Mysterious fog? A particular building or vista? The way people move? Their dress? Whatever it is, remember it. First impressions are invaluable sparks to creative interpretation, and by definition are not repeatable. You've seen the place in pictures, you've read about it. Now you're there, and all your senses can partake.

Research does not end when you arrive. The hotel lobby may have brochures for all sorts of sites and tours. Take them back to your room for study. If there is a tourism office, go there to see what information and pamphlets it has and be sure to arm yourself with a good map. Look at postcards in gift shops. Like the books you pored over at home, postcards will tell you what are generally considered the place's attractions and will give you ideas for how to photograph them. Talk with the receptionist, the bellhop, cashiers, policemen, waiters—anybody who is local and willing to let you pester them. Ask them what they like about the place where they live and the countryside around it. Talking with local people can reveal little-known features or interesting characters who may be ignored by the books and articles. What about their town, village, or wilderness area are they proud of? What do they think makes it special? Local people know a lot more about where they live than you or the writers of guidebooks ever will. You want to learn as much as you can about the place, immerse yourself as far as possible in it. Otherwise you won't know what to shoot, or how best to portray it.

As you do your research—both pretrip and after you've arrived—take notes. Organize the

notes into categories: overviews such as landscapes or cityscapes; morning, midday, and evening activities; important buildings, statues, squares, or other landmarks; economic activity; social activity. The list should reflect your own interests and passions. If you want to make a decent record of the place you are visiting, you need to cover the basics: what the place looks like and what makes up the natural or human life there. Express your own tastes and preferences within each of the categories. If you like, concentrate on just one or a couple. Whatever you do, it helps to have lists—especially if you are traveling to several different places and have limited time.

As you organize your notes, try to think of a theme for either the whole trip or for particular parts of it. It helps greatly if you pretend that you have an assignment—just give yourself one. It might be a general assignment that encompasses a bit of everything a place has to offer, such as "I am here to do a city story about Paris," or a more specific one, such as "I am here to do a story about the cafés on the Left Bank in Paris." If you don't have a theme, or at least an idea, you stand a good chance of being overwhelmed by the plethora of photographic opportunities. When we arrive in a new place, everything seems fresh and new and different. All our senses seem to be more acute, we notice details we would walk right past at home. We want to photograph all of it, but of course there's not enough time for that. A theme and its attendant lists will help you stay focused and make the most of your limited time.

Get out there. The only way to discover the rhythm of life in a place, and so figure out what to shoot, is to experience it. Many places, particularly hot ones, are active very early in the morning and late in the afternoon but rather in a lull around midday. Get up early, stay out late. If you

FOLLOWING PAGES: A fast shutter speed was necessary to freeze this young herder doing a back flip off one of his water buffalos in the Turag River in Bangladesh. Notice how the photographer placed the main subject off-center in the frame.

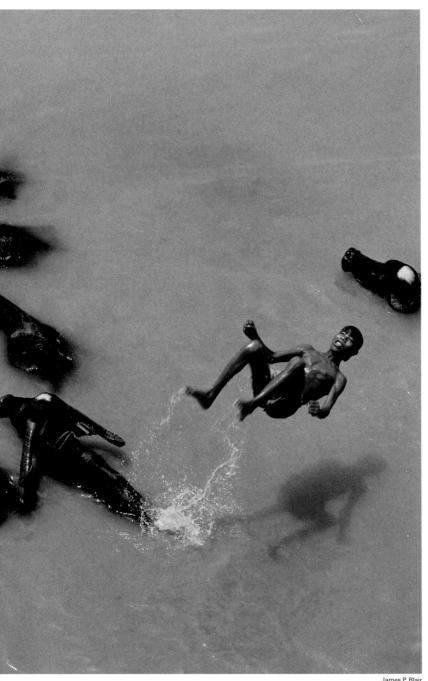

James P. Blair

are on a tour that is scheduled to leave the hotel or ship at 9:00, get up well before dawn. Wander around before meeting up with your companions. If the tour goes back to the hotel or ship for lunch, don't go with them. Rather than take the bus back at the end of an afternoon tour, hang around until after sunset and then take a taxi. Use any spare time to get out and look for photographs. Besides availing yourself of more opportunities, time spent discovering the place will enrich your experience.

Get lost. Wander down alleys. Sit in cafés and watch life pass by. Don't eat where the tourists do, but where you see locals. Just set off down a street and see where it leads. Look around the bends, over the rises. Get away from the crowd. I find that if I meander away from the tourists and tourist sites, away from what is too familiar and comfortable, it's much easier to adapt to the rhythm of a place, and to be more observant.

Always have your camera with you and always keep your eyes open. Serendipity plays an enormously important role in travel photography. You never know what you are going to run into, and you have to be ready. Many times you will see what could be a good photograph but decide that the light is not right, or there are no people around, or too many—something that means you will have to come back later. But sometimes you get lucky. You happen to stumble upon a scene at just the right moment. If you forgot your camera, are out of film, or your digital card is full, if you have to fumble around getting the right lens on, the moment may be gone before you can recover. This is true whether you are doing street photography or visiting a natural or man-made site. Mountains, trees, monuments, and other static subjects are, of course, not going to go anywhere, but the ray of sun-

Tip

Getting lost is a great way to meet people. Don't be shy about asking for directions.

shine, the soaring eagle, or the embracing couple that add the needed element to your photograph are unlikely to hang around. Think of it as hunting—whenever you leave the confines of your camp, you should be ready and able to capture whatever pops up.

Make time for photography. Like doing any-

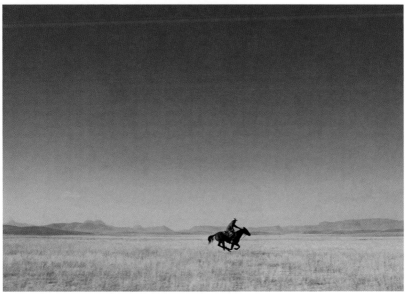

William Albert Allard

thing well, making good photographs requires a commitment of time and energy. One problem with much of modern travel is that the days are chockablock full of scheduled tours, events, and meals. Our trips are usually of limited time, and we naturally want to see as many sites as possible. The itineraries rarely leave room for serious photography. You have to make time. It may help to make photography a scheduled part of every day, so you know you have the time and won't be tempted to get lazy and say, "I'll do it tomorrow." It might rain tomorrow. Don't procrastinate.

Remember those first impressions and try to

The plains of Texas are about wide open spaces and big skies, so the photographer gave this cowboy and his horse a lot of room to run. A fast shutter speed froze the horse in mid-stride.

A wide frame of these costumed carnival-goers allows us to see a bit of Venetian architecture and the wet stone street, thus giving the image more atmosphere than a tight shot would have given.

imagine ways to convey them through photographs. Think of adjectives you would use to describe the place to friends. The adjectives will help you figure out how to approach the subject—whether to use a wide-angle or telephoto lens, what angle suits it, what light is most appropriate, etc. But techniques do not make good

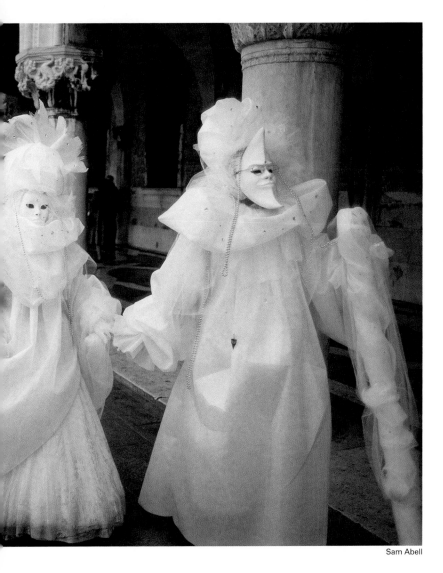

Sam Abell

photographs. They are tools that help you express an idea photographically. If you are aware of your feelings about a place, you can employ the techniques of composition and gear to help you communicate them. But it all starts with an idea. That is the sense of place you want to bring home.

IRA BLOCK
Playful Creativity

Leonard Kamsler

IRA BLOCK IS A NATIONAL Geographic photographer in the classic mode, a master at photographing anything, whether it be landscapes, people, artifacts, or complicated concepts. It all started when he was a teenager in the basement of his Brooklyn home, where he and his father built a darkroom. "I loved working in that little darkroom, watching the images appear," he recalls. "It was magic.

"Photography was a great hobby, but the film, developer, and paper quickly got beyond my means. The only way I could keep on was by trying to sell pictures—I'd photograph people in the neighborhood and sell them prints. People actually bought them."

Block's enthusiasm led to after-school and weekend work as an assistant to a local studio photographer and then to the newspaper at the University of Wisconsin.

"I started off covering sports," he says. "There were always photographers from the local paper and wire services there, and it wasn't long before I got friendly with them. Then the Wisconsin *State Journal* hired me part-time. Photographing for a newspaper is a great learning experience. The photographers there were great, and taught

Ira Block (left) is a master at photographing difficult subjects like this cliff dwelling at Mesa Verde in Colorado. Block left the shutter open for more than three minutes

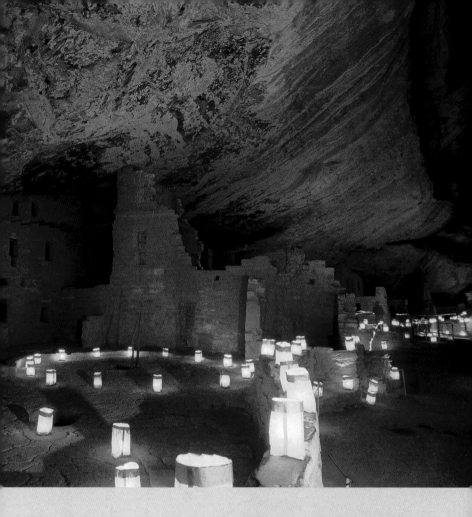

while he and an assistant ran around painting the scene with flash units. The result is an evocative image that gives us a feeling of the site's history.

me a lot. I'd get an assignment, run out, shoot, come back, process the film and select the pictures—two or three times a day. You could see right away what worked and what didn't. It was instant feedback, and a whole lot of practice. It was the time of the Vietnam War, so there was lots to cover."

Block ended up back in New York freelancing for *Sports Illustrated* and other magazines. Like many young photographers, he had his eye set on National Geographic, and it wasn't long before he wrangled his way in to see Robert E.

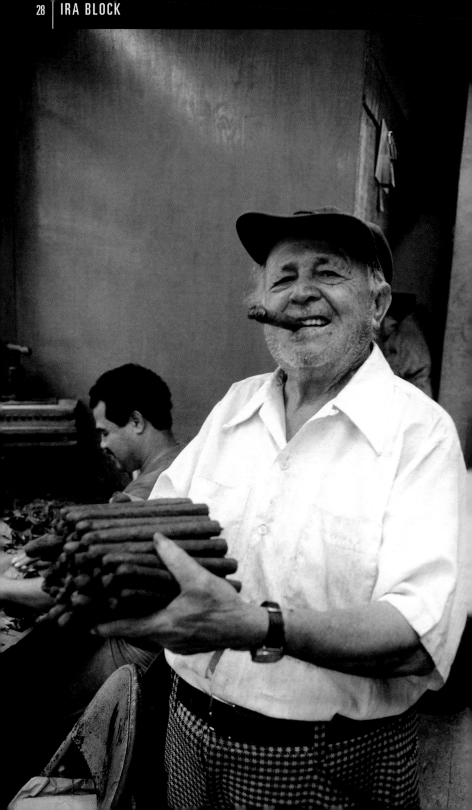

Gilka, the Society's director of photography.

"Mr. Gilka gave me some film to shoot a buffalo roundup in Montana—he wanted to see what I could do. I guess it was good enough, because he started giving me work for *World*, the Geographic's children's magazine, and for the Book Division. In '77 I was assigned to a story about the continental shelf that they'd been having trouble with. I came up with the approach of looking for unusual things that were going on, not just the expected."

Looking beyond the expected has been a hallmark of Block's work for Geographic ever since, work that has taken him from the North Pole to the Australian outback and dozens of places in between. In all of his stories, Block has come up with unique images, but he starts out in the same place as everyone else: with research.

"First I get a map and look carefully at it to get an idea of the geography of the place and familiarize myself with its landmarks. Then I go through books and magazines to get a feel for what the place looks like. I need to see photographs—it's too easy for writers to throw in adjectives that may or may not be reflected in the reality. By the time you get to your destination, you should know what distinguishes it, why you are doing a story about it, and what the key elements are.

"When you arrive, pay attention to everything, even little details. Clothing makes a big difference. A person in casual clothes says one thing about a place, someone dressed formally, something else. By going to different neighborhoods and types of events, you get a rich and varied look at the people.

"I've noticed a very strange thing in the years I've been working for Geographic. It's getting harder and harder to photograph people in the U.S. and recently in Western Europe too. People are inside all the time—watching television, at their computers, or at a mall. I spend a lot of time

Block photographed this cigar roller in Puerto Rico in a room lit with florescent lights, but got good color rendition by using a filter and a small flash unit. The man's smile—and the cigar in his mouth—makes the image memorable.

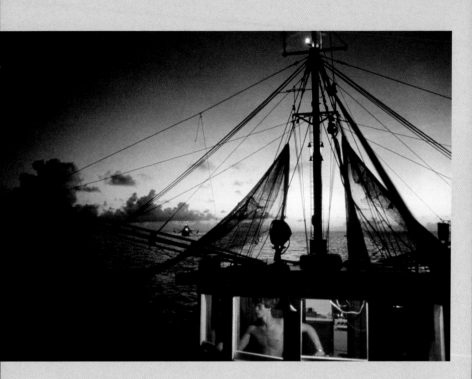

A flash unit with a warm filter to emulate tungsten light illuminates the shrimper and wheelhouse at dawn off the Florida Keys. It's important to balance the flash with the light in the sky.

trying to find out when they'll be out and doing things, when they'll be interacting with other people."

Whatever he is photographing, Block sees the challenge as the same:

"How do you make images that look interesting and dynamic but also respect the integrity of the subject? To do that you need knowledge of your tools and an understanding of and appreciation for light. And most important, you have to think, 'What is the character of the subject, and what am I trying to say about it?' The character of the place should determine everything—the light you photograph it in, the weather, the composition, angle—everything.

"Most people see an appealing vista and just shoot what they see, a wide-angle shot of a large expanse. But our eyes and brains work differ-

ently from film. Wide-angle lenses make things small, and you usually end up with a big, boring scene in which nothing stands out. You need some anchor, something to weigh the landscape down and be a reference point. Never be satisfied with what you first see. Work the situation over. Come back for better light. Try different angles, different lenses. Get your feeling about the place into the frame. Good photography takes work."

The reward of that work is not just in the photographs Block has made at the bottoms of oceans, the tops of mountains, cities, villages, laboratories, and factories. It is something more personal:

"My favorite kind of assignment is when I get to meet interesting people. When the culture—either the human or the intellectual culture—is different enough for me to be fascinated by it. When I can learn from it. When I walk away enriched."

Block's Photo Tips

- Think about what you are photographing. If it's a bustling city, don't shoot on Sunday morning when it's empty, but when there's lots of traffic and people on the streets.

- Scout for vantage points. Looking down into both landscapes and cities can help give a sense of place, so look for hills, tall buildings, or anything you can climb.

- Travel light. I usually carry two camera bodies and three zoom lenses. Often you can't move yourself forward or back, and zooms allow you to control the composition.

- If you don't want to lug around a big tripod, carry a little one you can set up on a table or a ledge.

- Don't make night pictures when it's pitch dark, but at dusk. The images will look like they were made at night, but you will pick up more details.

- If you are taking film overseas, remove the film from the canisters and put it in clear plastic bags. This makes it much easier and quicker for the security folks. Send the canisters in your checked luggage so you can use them to protect the film later.

- Take as much of your gear on the plane as you can. You want to be able to work if your bags get lost.

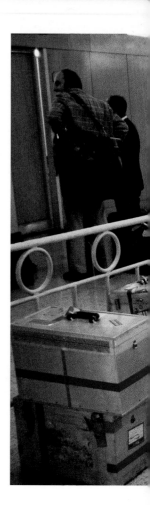

IT'S ALWAYS TRICKY. You want to take enough gear to be able to cover any situation you run into, but you don't want to be so overburdened that carrying it around is a hassle and slows you down. If you are traveling off the beaten path, you won't be able to buy batteries, film, or digital cards, so you have to carry enough for however long you're gone. If you're using rechargeable batteries, you need access to electricity. In foreign lands, you may need a voltage converter; you will certainly need plug adapters. There won't be anywhere to get things fixed, so you probably need at least a backup camera body. If you're backpacking you have to tote it all. If you're driving, on a cruise, or have porters, you still have to herd all the stuff into and out of airports and hotel rooms. Finding the balance between what you need and keeping the burden to a minimum requires careful planning.

My own kit ballooned to 13 cases full of gear at one point several years ago. I had extra camera bodies, a variety of lenses, a tripod, a couple of hundred rolls of film, boxes of batteries, lights, light stands, reflectors, diffusers, remote triggers, cables, and I can't remember what else. Since I was traveling in very remote areas, I also carried a medical kit, camping stove, sleeping bag, water purifier, some emergency freeze-dried food—oh, and a change of clothes. Just keeping track of it all was a nightmare. Luckily, advancing technology and my own experience now

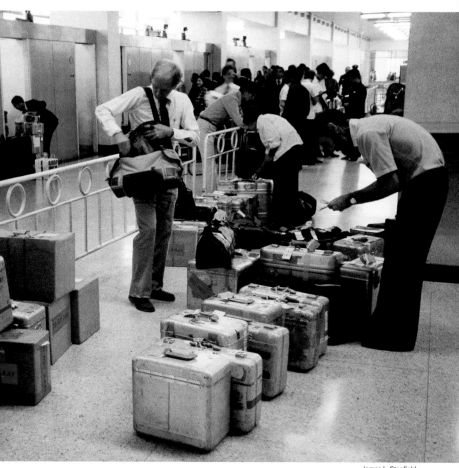

James L. Stanfield

allow me to do more with far less. In those days, for example, most zoom lenses were not quite as sharp as fixed focal length ones. Now they are, and one zoom lens can cover what used to require three or four fixed focal length lenses.

Figuring out what to take depends largely on what you know about your trip—there's that research thing again. If you are going on safari in Africa, you will need long telephoto lenses to get decent images of the animals. Long lenses usually require using a tripod, which is also

Too much stuff. Photographers Jim Brandenburg and James Stanfield keep track of cases and boxes of gear in the Beijing Airport in China. Unless you are a professional and really need a lot of gear, keep it to a manageable level.

necessary if you plan to shoot in dim light using long shutter speeds. If you're going diving, you will need underwater housings. If you are going caving, you will need lights. Special situations require special gear, and you should think carefully about what you plan to photograph and make sure you take along what you need to get the job done. We will cover some of these in the chapter on Travel Subjects. Here we will talk about the basic, don't-leave-home-without-it gear, assuming that most people will be shooting "normal" subjects and won't want to take too much more than will fit into a reasonable size camera bag. You don't want a camera bag to be too heavy—it's hard to be mobile with a backache.

Nikon, Inc.

Full-featured top-of-the-line 35mm SLR film cameras like the Nikon F6 (above) offer an enormous array of lenses and other accessories as well as both automated and manual controls, built-in motor drives, and a host of other features.

Most professional photographers travel with 35mm single-lens reflex (SLR) film cameras and/or SLR digital cameras. The information in this chapter is about them but applies to other film formats and other digital cameras as well. If you don't have all of the stuff mentioned, or are traveling in a way that means you can't carry much, don't worry. The old saying "It's the singer, not the song" applies. Gear does not make photographs. You do. What you have is far less important than what you do with it. Many great photographs have been made with very simple cameras.

What to Take

Camera bodies

Today's camera bodies are sophisticated and rugged, and for most types of travel one camera body is enough. Most professionals use SLR cameras because of the availability of a wide variety of lenses and accessories and because what

you see is what you get. Some prefer range-finder cameras. The important thing is to choose a camera that you feel comfortable with and that will facilitate your image making. If you are going off to remote areas, especially if for an extended time, take a second body as a backup.

Top-of-the-line 35mm SLR film cameras have a bewildering number of features and functions, but, unless you really need these, may not be worth the extra expense and burden. They tend to weigh more than the major manufacturers' No. 2 or 3 offerings, which often have many of the same features. Think about what you need in a camera, and use one that meets those criteria.

Many digital SLR cameras mimic their film counterparts. If you have film and digital camera bodies from the same manufacturer, you can use the same lenses on both, and the handling will be familiar. Some of the smaller, less expensive digital cameras are quite good but are similar to film point-and-shoot cameras in that you cannot change lenses, and the ones they come with may not be as sharp, especially in the electronic zoom mode. You also cannot use separate electronic flash units with most of these, but are limited to the built-in ones, which give you far less control. Because the cameras are smaller, their digital files don't hold as much information as the files of their big brothers. If you are shooting for Web sites or a family album, either paper or electronic, one of these smaller cameras may be fine. If you want better quality images to work with and to print large, or if you are shooting for publications, you will probably need one of the professional-grade digital cameras.

Canon USA, Inc.

Second tier digital cameras like the Canon EOS 20D (above) offer a full range of features for less cost than their top-of-the-line brothers, but smaller resolution image size in terms of megapixels.

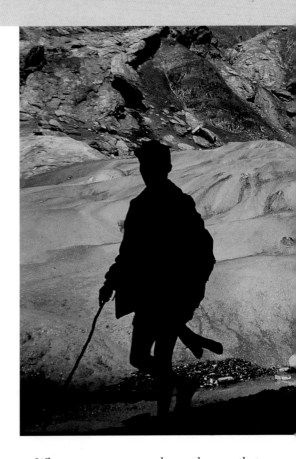

Whatever camera you choose, be sure that you are thoroughly familiar with it before you go on a trip. If you are planning to buy a new camera for the journey, don't wait until the day before you leave. Buy it well ahead of time. Shoot pictures with it. Spend time learning where all the buttons and dials are and what they do. Many modern cameras have a dial near the shutter button that changes the aperture rather than allowing you to change it on the lens, as with older models. It can take a while to get used to the new location and to automatically know which way to turn it to increase or decrease the diaphragm opening. You don't want to find yourself in a wonderful situation and waste precious time staring dumbly at unfamiliar gear. The moments you want to capture are often fleeting.

Robert Caputo

Lenses

As I mentioned above, the optical qualities of modern zoom lenses are almost equal to fixed focal length ones, so you can easily get by with carrying just two lenses to cover most ordinary subjects. For example: A 17-35mm zoom gives you quite to moderate wide-angle; an 80-200mm covers short to medium telephoto—this is on a 35mm film SLR. Remember that the same lens on many digital SLR cameras gains about 1.5 to 1.6 times its focal length: A 17mm lens effectively becomes a 27mm lens; 200mm becomes 320mm.

Nikon, Inc.

Wide-angle lenses allow us to capture enough of a subject's surroundings to give our images a sense of place. Extreme wide-angles like this 14mm lens are good for working in tight places.

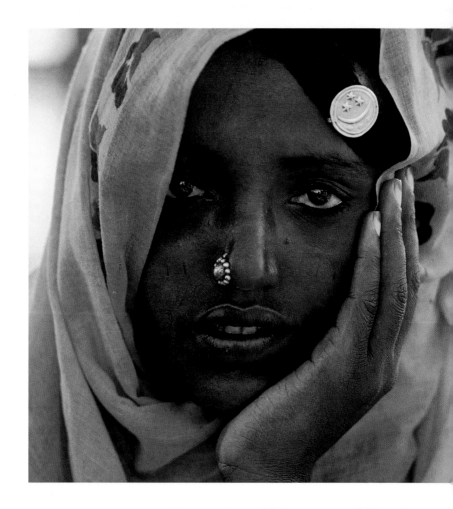

Some newer models have corrected this and keep the 35mm film equivalency. Check the manual of your digital camera to find out which category yours falls into.

One thing to consider when you are selecting lenses is speed, or what the maximum aperture is. In general, the wider the maximum aperture, the larger and heavier a lens is, and the larger the cost too. Having fast lenses (usually f/2.8 for zoom lenses) is a great benefit for shooting indoors or in low-light situations, so if you

Robert Caputo

Nikon, Inc.

Portraits are best made with focal lengths of 85mm or longer, such as the high end of the 24-85mm f/2.8 zoom shown above. The longer focal length flattens features a bit and is more flattering. It also helps you not crowd the subject.

know you will be doing a lot of photography in those circumstances, they may be worth the extra weight and cost. Having just one more f-stop can often mean the difference between getting the shot and missing it.

Carrying two zoom lenses like the ones

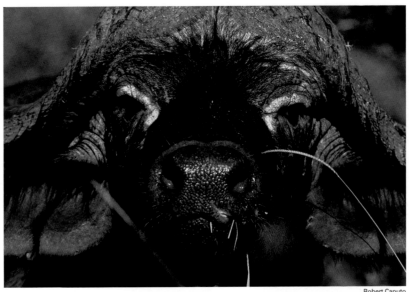

Robert Caputo

mentioned above leaves you without an extreme wide-angle, a so-called normal lens (50mm in 35mm film photography), or a long telephoto. If you know you will be working in small spaces, you may want to augment your kit with a 14mm or similar lens. If you like the aspect of 50mm, either take one along, buy a zoom lens that covers that focal length rather than one of the others, or take three zooms that cover the whole range. If you plan to photograph sports, animals, or something that requires more reach, take a long telephoto. If you want to shoot small details of plants or other subjects, take a macro lens that allows for extreme close-up work. Again, think hard about the kind of photography you like and will be doing, and what lenses you need to get the photographs you want. I would guess that I spend 75 percent of my time in the field with just three lenses: 14mm, 17-35mm, and 80-200mm. If I'm doing specialized work, I supplement those with what the situation calls for.

Nikon, Inc.

Short to medium telephoto lenses like the 80-200mm f/2.8 above give you great reach for street photography, wildlife, and a whole range of other subjects. The portrait of the cape buffalo at left was made with a 600mm lens.
I didn't want to get too close.

Other Important Things

Many of the huge number of accessories available for photography are a matter of personal choice, but I have found the following items quite handy when traveling:

If you take a tripod, be sure it is sturdy enough to give you the support you need but light enough to be transportable. A flimsy tripod is worse than none—it won't be sturdy enough to hold a heavy lens, and you will still have to lug it around. Carbon fiber tripods offer a good combination of sturdiness and light weight, but they cost more than metal ones. If you don't want to or can't take a full-size tripod, get a small "table pod." It won't be strong enough for long lenses (you can use a bean bag, a pillow, or your camera bag for those), but it will stabilize a camera and smallish lens for long exposures. It can be placed on a table, as the name implies, or on a ledge, shelf, or just about anywhere. A cable

release or other kind of remote trigger allows you to set off the shutter without jostling the camera when you are using long shutter speeds. If you look, there's always somewhere to set and stabilize your camera. Never say, "If only I had a tripod."

Skylight filters protect the fronts of lenses and cut down haze. A polarizing filter can deepen the color of the sky and reduce glare from reflections. When you are using a polarizing filter, though, don't fall in love with the way it makes puffy white clouds in a blue sky look. Although such scenes really do look gorgeous, they also tend not to look real.

Bring a small, tilting-head electronic flash unit, preferably with a diffusion cap. Also take a con-necting cord so you can hold the flash off camera. If you are traveling with both film and digital cam-eras, be aware that some flash units work on both and some don't.

Be sure to take plenty of batteries, film, and/or digital cards. If you are traveling to remote places there may be no place to purchase more. Even if you are traveling in countries where they are avail-able, you may not find the type you like, and they may be considerably more expensive than at home.

Film type is again a matter of personal choice. Most professional publication photography is done on color transparency film, as it offers the best color rendition and grain. Different film stocks render colors differently, though, so you should experiment with several different ones before you leave to see which you like best. Then buy in quantity to take advantage of discount prices. Unless you are shooting in extreme situa-tions, one film type should be enough. I travel with 100 ISO film, which is plenty of speed for almost

Nikon, Inc.

Close-ups of large subjects like this lizard can be made with telephoto lenses. For smaller subjects and for detail work, macro lenses like the one above are a must.

Robert Caputo

all situations. If I need to, I can "push" the film and expose it at 200 ISO or even 400 ISO without too much loss of quality. Most modern films can be pushed. Just make sure you mark the canisters of exposed film and alert the lab so it will process the film properly. Check with your lab in advance to make sure they offer this service and just how much of a push they recommend for your specific film. Generally speaking, color slide films respond well to a one- or two-stop push, but color negative films do not push well at all.

If you are shooting digitally, take extra digital cards. They can go bad. Also take a laptop computer or other kind of portable storage device. Portable hard drives are reasonable in price, and some have built-in card readers so you can dump your images quickly and easily. There are also devices that let you copy from your digital cards onto inexpensive blank CDs in the field via battery power or in your hotel room using an AC adapter. Make a habit of regularly downloading your cards. This frees up space on the card and helps assure you won't lose your images. Also take extra batteries for the camera and laptop or other device and be sure you have the right adapters and plugs to be able to recharge them. If you are traveling to remote places, you might want to get an adapter so you can charge batteries from your car. If the place is really remote, a solar charger will make sure you don't run out of power.

Nikon, Inc.

Tilt-head flash units are a must-have portable source of light. High end ones offer automated features for fill flash and other control, and can be used off or on camera.

Odds and Ends

A camel-hair brush, air bulb, and lens-cleaning fluid and tissue will keep lenses and bodies clean. A set of jeweler's screwdrivers is handy for making repairs. If you are going where it's really humid, take silica gel. Keep it in an airtight case or in sealed plastic bags with your gear.

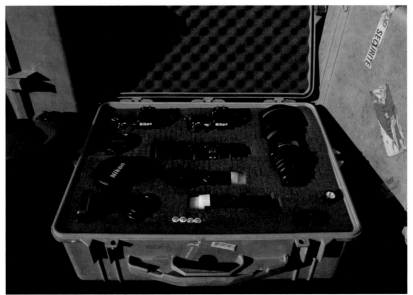

Robert Caputo

Hard-shell cases protect cameras and lenses from jolts and crushing, and many are waterproof and dustproof. Place your gear on the foam rubber to figure out the optimum arrangement before cutting the foam.

How to Pack It

Protecting your gear

Now, what to do with all this stuff. Again, it depends on where and how you are traveling. If you are traveling light and the delicate stuff (cameras and lenses) fits into a camera bag, you can take it as carry-on luggage. The rest of your gear, not breakable, can be carefully packed into a checked suitcase. If you are going hiking, several manufacturers make backpack camera bags that can hold a basic camera kit as well as some clothes. These are generally small enough to meet carry-on size requirements. If, however, you have a lot of gear and use your carry-on allotment for a laptop computer or other things, you should take camera cases. The best camera cases are either hard plastic or aluminum, and should be at least dustproof and

preferably waterproof. Many of these come packed with foam rubber, which you can cut out to accommodate your camera bodies, lenses, flash units, and anything else that benefits from being protected against jolts. Before cutting, place all the gear you want to carry on top of the foam rubber and move it around to find the optimal arrangement. It's best to place heavy items at the back so they will be on the bottom when the case is standing on edge. Be sure to leave enough foam rubber around the sides and between items to prevent rubbing, and tall things should be put sideways to prevent them from being crushed.

If you don't have camera cases, I would still recommend something with a hard shell. Wrap your gear in clothes and put it in the middle of the bag, with more clothes all around.

Most camera cases can be locked with either padlocks or numeric dials. Lockable cases are a must if you are traveling to places with uncertain security, but most airports will not allow locked cases onto planes. There are now special FAA-approved locks that can be put on your luggage in advance. Inspectors have a master key and can open and inspect the bags if necessary and relock after inspection. Find out what the routine is at your local airport. Some screen baggage in the check-in hall, and if you hang around until your bags have been inspected, the agents will put a lock on for you. If bags are screened in another part of the airport, put an open padlock (if you're using one) and a note on top of the stuff in your case. The note should explain that you are traveling overseas and politely ask the agents to please put the padlock on the case, or to please spin the numeric dial after inspection.

If you are traveling overseas without too much gear, you should have no problems with

Courtesy Lowepro USA

customs agents either at home or abroad—everyone is used to tourists traveling with cameras. But if you're taking a lot of foreign-made equipment, you may need to register it with customs before you leave—otherwise they may think you bought it overseas and are importing it, and may want you to pay duty when you return. You can register your gear at any international airport before leaving, but be sure to give yourself plenty of time. Take a typed list of all the gear and serial numbers. Make several copies so you can use the same list when you arrive in a foreign country. Don't forget that many countries require entry visas. Check with their local embassy to find out what the requirements are.

Traveling with film poses a real dilemma these days. Because of heightened security at airports all over the world, x-ray doses for carry-on have increased, checked baggage is x-rayed with very powerful machines, and agents at some

Camera bags offer protection for your gear and a place to carry often used accessories. Try not to load them up with more than you need; it's hard to make good photographs if you have a backache.

airports are reluctant to hand-inspect film. (Some airports refuse to hand-inspect at all—either it goes through the machine or it doesn't get on the plane.) In order to avoid hassles as well as potential damage to your film, it's best to ship the film to yourself, though this works well only if you ship within the United States, within the European Community, or somewhere else you don't have to worry about customs. Find out the address of the hotel where you'll be staying, package the film, and take it to one of the commercial delivery services that operate between your home and your destination. If you're not staying in a hotel, send it to a friend or business contact or for pickup at the shipping company's office. At the end of your trip, ship the film back to yourself at home.

If you are traveling to a place where shipping doesn't work because of customs duties or hassles, go online or in some other way try to find out if you can buy your favorite film in your country of destination and what it costs there. Call the major film manufacturers and find out where they make their films. Ask if they have suggestions for where you might buy it. If you're going to Japan, for example, you should be able to arrange to buy Fuji film quite easily and reasonably, especially if you are buying a lot.

If you discover that you can't buy the film you like at your destination, or if the price is ridiculous, you will have to hand-carry it. If your nearest airport has a "no hand inspections" policy, try to find another one that does. Then be very courteous, friendly, get down on your knees and beg the agent to let your film on the plane without passing through the x-ray machine. Security agents are never very happy about hand-inspecting film—it takes a lot of time, and their thumbs get sore from opening all the canisters.

Once You're There

If you are staying in a place to which strangers have access, it's not a bad idea to keep your equipment in locked cases when you are away. It's not that you don't trust the maids, fellow campers, or whomever, but simply to be safe. In very poor countries, a camera body or a lens may represent several months' worth of wages, and it is not nice to tempt people. And if something goes missing it can be costly or even impossible to replace it. Padlocks with keys are the best: I once stayed in a hotel room long enough for someone to figure out the numeric combination on one of my cases by simple trial and error. If you feel the place is really risky, use a chain or wire bicycle lock to secure the cases to the furniture. Better to be overly cautious than not to be able to make photographs.

When you are wandering, keep your camera slung around your neck or over your shoulder, easily available for chance opportunities. But keep your camera bag closed. Most bags come with quick-release latches so you can get into them quickly. Keeping them closed prevents lenses or whatever from falling out if you bend over and also deters potential thieves. If you're worried about pickpockets, keep the bag in front of you where you can keep an eye and hand on it.

But never let stories about a place interfere with your experiences or photography. We all hear the tales of bad things that happen to people, and they can happen anywhere. But we rarely hear the stories of the thousands of people who had wonderful times and to whom nothing untoward ever happened. In 24 years of wandering the globe for National Geographic I've had very few bad experiences. In fact, I have found ordinary people everywhere to be generous and hospitable. Take reasonable precautions, then get out there.

Tip

Be patient and friendly with customs and security inspectors at home and abroad. They have a difficult job, and getting impatient with them usually means it just takes longer.

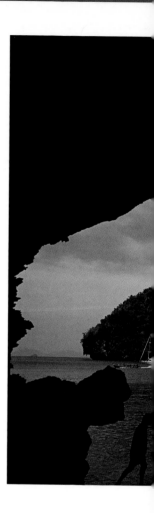

IN CHAPTER ONE we talked about the need to think about the place you are photographing and to understand what you want to say about it. Good photographs communicate the look and feel of a place, person, or other subject. Compositional techniques help you enhance the look of the subject and help get across emotional content. Both are equally important. If a photograph is not visually interesting, it is unlikely that anyone will spend time looking at it. If it does not stir some emotion, it will not make an impression. In the trade, we refer to pictures that are pretty but devoid of content as "eye candy." They are sweet, but empty of anything that might nourish you.

The compositional techniques in this chapter are guidelines. The best way to learn how they work is to look at lots of photographs and paintings—painters have used them for centuries. When you come across images that really appeal to you, study them to see how the artist achieved the effect he had on you. Deconstruct them. Think about the angle, the placement, and the relative size of the main subject, what's in the foreground and background, what's in sharp focus and what is not. Then look at some of your own photographs and think about how they could be improved by using one of the techniques discussed below. And practice—I cannot emphasize enough how important it is to practice. People who are accomplished at what they do have gotten that way by practice, no matter

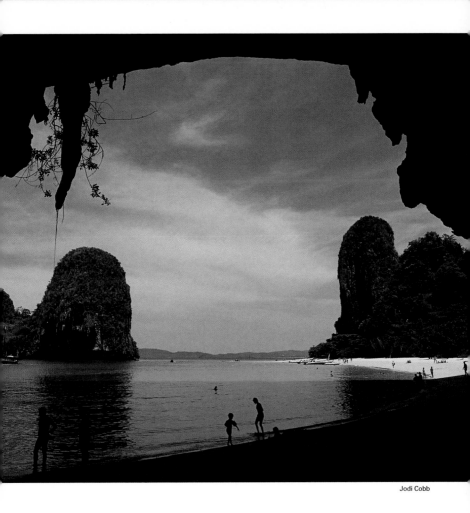

Jodi Cobb

what the field. In the arts, sports, medicine, law, business, the one thing they all have in common is that it takes practice to become good. Thomas Edison famously said, "Genius is 1 percent inspiration and 99 percent perspiration." With enough practice, you will stop having to think consciously about compositional techniques, just as you will stop having to pay undue attention to all the buttons and dials. When things fall into place in your viewfinder, it will feel right. Photography, like any art, is partly craft.

Bold compositions make for dynamic and interesting photographs. In this case, the photographer used a frame within the frame by including the top of a seaside cave. This technique gives us a very active sense of "viewing."

Placing the main subject a third of the way into the frame gives this image dynamism as well as detail of the woman and her net. The wide-angle lens and large depth of field also let us see the environment and how the nets are used.

Compositional techniques are tools just as cameras, lenses, and lights are. They can be learned, and should be in the same way that beginning art students learn to draw life studies. It doesn't mean that they will all end up painting realistic pictures for the rest of their lives, but it gives them a foundation to build on. In the same manner, these rules are not etched in stone—they are made to be broken when it is appropriate. Some of the best visual images ignore all the rules. In the end, a good composition, like a good photograph, is a personal choice. It's what works.

Everything Counts

The first thing to remember about successful composition is that everything in the image counts. When you look at a painting, it is easy to understand that the artist made conscious and careful decisions about every single item depicted there—you never hear about great paintings that need to be cropped. The same should be true of photography. When you look through the viewfinder, don't just look at the subject. Scan the entire frame area carefully. If something is distracting from your subject, or if something simply has no reason to be there, get rid of it by moving, changing angles, or using a different lens. If it is distracting to you, it certainly will be to a viewer. You will probably have to make a conscious effort to scan the viewfinder at first, but with practice it will become automatic. Also think carefully about subject placement. If a tree appears to be growing out of a person's head, move either yourself or the subject. One idea to keep in mind as you scan the viewfinder is, "Would I be happy to have this image in my photo album? Would I be happy to have a print of it hanging on my wall?" If the answer is no, don't take it.

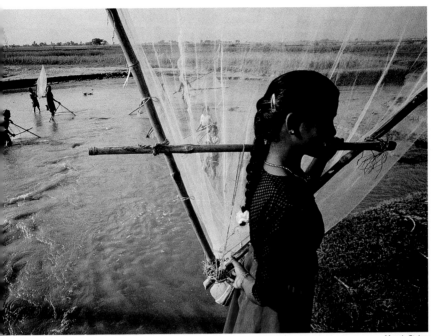

Maggie Steber

The Rule of Thirds

As you spend time looking at photographs and paintings, you will notice that more often than not the main subject of the image is located off-center in the frame; usually one-third from the top or bottom, and one-third in from a side. This is called the rule of thirds, and it is almost as old as visual imagery itself. To see how it works, simply draw lines over an image that divide it into thirds horizontally and vertically. The intersections of these lines are the "sweet spots."

We usually perceive a subject that is dead center in a frame as pretty boring. Our eyes go straight to the subject, find nowhere else to go, and so lose interest. This bull's-eye approach is the second most common fault of amateur photography. (The first is not getting close enough.)

FOLLOWING PAGES: This photograph of beach cabanas combines the use of leading lines, graphics, patterns, and the rule of thirds to create a very bold and striking image.

Steve McCurry

We all have pictures of ourselves or of loved ones that look like targets: the person's head smack-dab in the center, feet cut off, lots of empty space above and on the sides. It may be a good picture of Grandpa's expression, but people who don't know him will probably not be bothered to look long enough to decipher it.

Placing the subject a third of the way into the frame makes an image more dynamic; we perceive it as energetic and interesting. Our eyes are more willing to explore not just the main subject, but the rest of the image as well. We somehow understand that the composition was the result of conscious thought rather than just a quick point and shoot. We reward effort with effort.

But never think of this (or any other rule) as unbreakable. Sometimes the subject should be in the center of the frame. Where in the frame it belongs depends on what it is, what the environment around it is, and a whole host of other things far too numerous to mention. Study works

A boardwalk in Yellowstone National Park creates a classic example of a leading line. Notice that the photographer waited until the people were silhouetted against the steam.

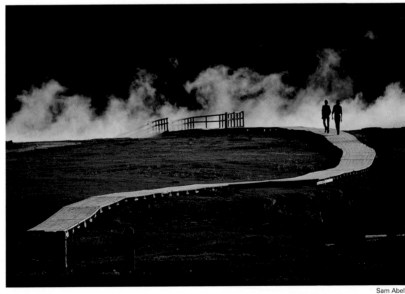

Sam Abell

in which the main subject is dead center and think about why the artist decided to put it there. How would it look and feel different if the subject were off-center? When you're making pictures, frame the subject off to the side and then in the center. Which do you like better?

Leading Lines, Foreground Elements, and Depth of Field

Photographs are two-dimensional representations of a three-dimensional world. To make up for the loss of the third dimension, we try to create images that give the illusion of depth—to use leading lines, foreground elements, and depth of field to pull the viewers' eyes into the picture.

A leading line can be something fairly obvious, such as a road or fence, or it can be more subtle like an arm or a bank of clouds. It normally enters the frame or begins near one edge and makes its way across the frame at an angle, often leading directly or indirectly to the main subject. It is a combination of graphic element and pointer, and very actively carries the viewer into the frame. We find it quite natural to follow leading lines with our eyes, just the way you round a bend and immediately look down a road that leads off toward the horizon. We almost can't help ourselves. You want viewers to be subconsciously drawn toward the subject and forget about everything that is outside. Leading lines are a powerful tool to help you do this. Find something near your home—a fence, a road, or some other linear element—and make pictures using it. Try different positions and angles: Have it go left to right, right to left, bottom toward top. Look for photographs and paintings with leading lines. Watch for them in movies and on television.

Tip

Practice and experimentation are the keys to doing anything well. Try different compositional techniques on your family and friends and study the results before you set off on a trip.

Sometimes, as in this photograph, it is best to break the rule of thirds. Placed in the center, the palm trunk becomes a strong graphic element.

Foreground elements also help the viewer enter the frame, and they can be almost anything: the near part of the road or fence used as a leading line, a vase on the desk behind which your subject sits, a boulder in a landscape, a sign at a rally, a statue in a garden. Or there can be several. Whatever it is (or they are) should be an integral part of what you are saying about your subject,

Jim Richardson

since an object in the foreground will be obvious
to the viewer. But you do not want it to overwhelm
your subject or even be equal in weight. Think of it
as a minor key to your main subject's major.

When you look through the viewfinder, think
of the scale. If the foreground elements are too
large and distracting, you need to eliminate some
of them or reduce their size by moving back.

Another way to de-emphasize them is to soften their sharpness of focus. That's where choice of lens and depth of field come in.

Depth of field is one of the most powerful tools a photographer has to control how a viewer will perceive a scene. In the real world, our eyes selectively focus on different items, each of which is sharp when we look at it, no matter how far or near. But in a photograph, the photographer has determined what will be sharp, and therefore emphasized, and what will be soft, or of less importance. He or she is telling the viewers what is important, guiding them through secondary objects to the subject.

Depth of field is the range of apparent sharpness in an image. It is determined by the focal length of the lens, the size of the aperture, and the distance between the main subject and the camera. We will discuss in more detail the properties of different lenses in the next chapter. Here, suffice it to say that the smaller the aperture, the greater the depth of field, and the shorter the focal length of the lens, the greater the depth of field. A very wide lens has great depth of field at almost any f-stop; a long telephoto will have very little even at the smallest one. If you want everything from the boulder at your feet to the distant mountain to be in sharp focus, use a wide-angle lens. Be aware that in a situation like this, a very wide-angle lens will expand the apparent distance between objects; it will push the mountain away from the boulder and make it seem small. It may also distort the lines of the boulder or anything else that is very close. A person's face shot with a wide-angle lens at short distance will look very round.

Telephoto lenses have the opposite effect. They flatten objects and compress distance—they make things seem closer to each other than they really

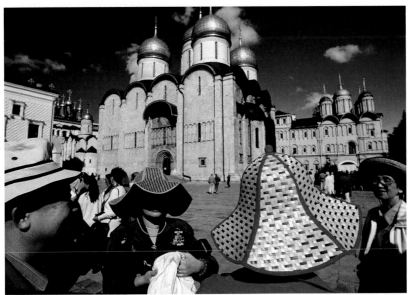

Gerd Ludwig

are. Because they have little depth of field, objects at any distance from your main subject will be soft, thus making them less prominent in the frame.

The best way to learn about depth of field is a simple exercise. Photograph the same scene with both wide-angle and telephoto lenses at large and small apertures and compare the look and feel of the resulting images. A friend in a crowd may blend in too much if photographed with a lot of depth of field. Shallow depth of field may make her stand out from it. A street scene may be too diffuse and confusing if everything is sharp, but striking if only the person leaning on the lamppost is.

If you are using a digital camera, you can see the results right away. Most 35mm SLR film cameras have depth-of-field preview buttons, so you can check it before you shoot. What you are looking for are the ways different depths of field affect your image. Determine what you want to call your viewers' attention to, and use depth of field to do so.

Foreground elements, depth of field—and humor—make this shot of a church in Moscow much more interesting than one just of the building. Notice how the photographer used the harsh light of midday to his advantage.

Always look for patterns and especially for the one element that breaks them, like the little girl in this pattern of uniforms. The different element will immediately stand out and add interest to the frame.

Graphic Elements, Angles, and Frames

Photographic composition makes use of graphic elements either to enhance the image or as a subject in their own right—some photographs are pure graphics. They can be colors, lines, shapes, patterns, or textures. When you look through the viewfinder, always be on the lookout for ways to use graphic elements to improve your image. Is there a block of color or shape that complements (or detracts from) your main

Sisse Brimberg

subject? Is there a pattern that your subject
blends into or stands out from? Graphic elements
add dynamism to photographs. Study the work
of photographers who use strong graphics and
the work of abstract artists.

The angle from which you make an image is of
primary importance, and there are certain con-
ventions about angles, especially when people are
the subjects. Looking up at someone is known as
the heroic angle—it makes the person seem
imposing. Politicians have long understood this

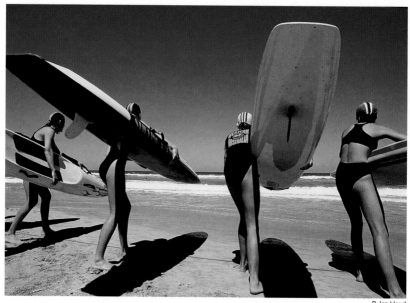

R. Ian Lloyd

The graphic lines of the surfboards and of the women's legs carry us right into this frame, making us feel as if we are headed into the ocean with them. A wide-angle lens enhances the effect of every-thing leaning toward the water.

effect. It's why they almost always give speeches from raised platforms but rarely let the news photographers covering the event onto the stage. The pictures are taken looking up at the orator, and he comes across in the papers the next day as authoritative. Hollywood uses this device too, when filming the hero. A downward angle on a subject implies inferiority. We're all familiar with the standard shot of the victim cowering at the villain's feet, looking up pleadingly.

The perception conveyed in every kind of photograph is influenced by angle. What does this angle say about the subject? Can I improve the image by squatting or lying down? Should I climb a tree or ladder? Never be satisfied with what you see when you first put eye to camera.

Angle is especially important when you are photographing children, people sitting down, pets, or anything shorter than you. We tend to walk around when we are making pictures, moving to

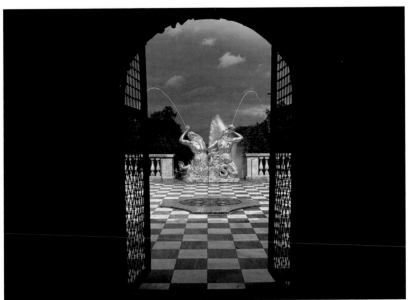

Sisse Brimberg

get the best light on the subject or incorporate something into the background. We pay a lot of attention to horizontal angle, but snap happily away without being conscious of the vertical one. Then we see the images, and the subjects all appear to be straining their necks to look up at us. Eye level, no matter how low or high, is much more intimate, and devoid of inherent implications.

Every photograph, of course, has a frame—the edges of the image. But also look for ways to use frames within the frame. Some, like doorways and windows, are quite literal. Others—leafy branches hanging from a tree, parts of people in the fore-ground—can be more subtle. Their use adds depth to the image and helps focus attention on the main subject. Often, an internal frame conveys a very active sense of viewing—we feel that we are in the place and peering through the frame to the subject. When looking at others' work, notice how their use of framing makes you feel about the scene.

By using an arched doorway to frame this image of golden fountains, the photographer makes us feel that we are inside looking out. Be careful metering in situations like this, as the dark area on the sides of the frame may fool your meter.

Choosing the Right Lens

AS WE MENTIONED IN the last chapter, different focal
length lenses have their own properties. Wide-angle
lenses encompass more and have great depth of
field but increase apparent distance and may distort
things close to the lens. Telephoto lenses flatten sub-
jects, have little depth of field, and have a narrow
view. Next time you watch a movie or television
program, watch for a shot where the camera moves
in on or away from the subject. If you pay attention
to the background, you will easily be able to deter-
mine if the cameraman was zooming in (the back-
ground gets closer to the subject) or using a fixed
focal length lens and dollying in (the background
stays in the same relative position). The effects of
these two are quite different. To understand the
effect even better, make a picture of someone, say
from the waist up, in front of a wall, tree, or other
large background that's a good distance from him
or her. Make it first with a telephoto lens. Then,
moving closer and keeping the person the same size
in the frame, make the same picture with a wide-
angle. Look at how different they feel, what they say
about your subject and the environment, and what
is emphasized or de-emphasized.

As you wander through a town or forest, think
about what kind of pictures you are likely to be
making, and mount the lens that is most appropri-
ate. For general photography, two zoom lenses—a
wide-angle one and a telephoto—should cover
most situations. If you like making portraits or

Joel Sartore

fairly tight shots, mount the longer lens. If you're after wider coverage of the scene or are working near your subject, use the short one. The important thing is to have one on and ready so you can capture those moments that go fleetingly by.

Choosing the Right ISO

If you know that you will be shooting in low-light situations—in a forest, perhaps, or indoors—think about the ISO rating of your film or digital imaging. You want to be able to get the shutter speed

Photographer Joel Sartore needed this big telephoto lens to shoot wolves for a NATIONAL GEOGRAPHIC magazine story about Yellowstone National Park. When setting out on a trip, think about what you will be photographing and take the gear that is appropriate—not more, not less.

and aperture combination that best captures the scene: If you want to avoid blur caused by either subject or camera motion, you probably don't want to shoot at anything under a 60th of a second, and that's if the subject is reasonably still. If you are using film, choose one that has a higher ISO rating or push the film you have. Remember that ratings of 400 ISO or higher start to show grain and may not render colors as well as lower rated film. If you are pushing film, say 100 ISO to 200 or 400, check before you leave to make sure your local processor can do it, and remember to mark the film canisters appropriately. Most higher-end digital cameras allow you to change the ISO rating, and you may need to select a high one for some subjects. Of course, you may want visible

Both of these images were made from the same location and each gives us different information and feeling for the temple at Kom Ombo in Egypt. The top image was made with a 35mm lens; notice how the seated figure gives the picture scale. The bottom image was made using a telephoto that compressed the pillars together.

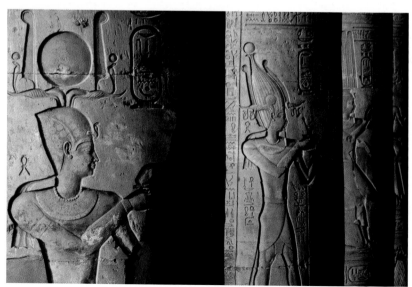

Robert Caputo (both)

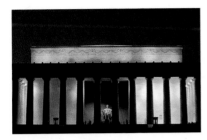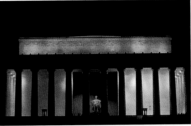

Robert Caputo (both)

Same scene, different film. Two images illustrate how different film stocks render color differently. Lights on monuments and buildings may have odd color characteristics; you may have to experiment with film stocks or white balance to get the look you like.

grain, blur, or other effects caused by using a film or digital exposure rating that is higher or lower than a "normal" exposure would call for. Some photographers like the grainy look and use it all the time. Others incorporate some blur into almost everything they do.

Color Rendition

The films we use most commonly are made to accurately render colors photographed in sunlight, and are called daylight films. If you shoot in places lit by incandescent lightbulbs, photographs made on daylight film will look yellow. If this is not what you want, you can use a filter on the front of the lens to color-adjust the film, but you lose a little speed when you do so. You can also choose a tungsten light-balanced film that will render the colors naturally. If you are shooting with a digital SLR camera, you should be able to adjust the white balance to get the colors to look the way you want. Remember, though, that if you are using unfiltered light from an electronic flash, the light from it will be the same color temperature as sunlight. Many photographers do not mind the warm, yellowish cast, as it conveys an intimate, homey feel.

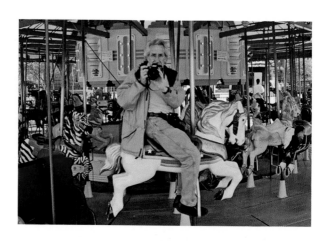

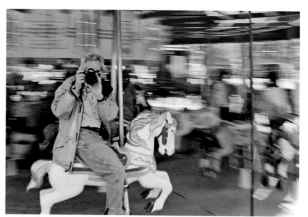

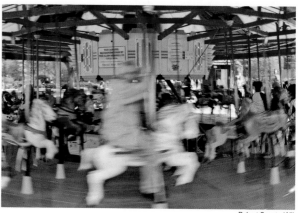

Robert Caputo (All)

Shooting in rooms lit by florescent bulbs, however, can be a nightmare. The problem with florescent is discontinuous spectrum: Certain wavelengths are simply absent. The only solution is to know which kind of florescent lamps are in use, for all to be the same, and to use a Singh-Ray florescent filter for that type of lamp and the type of film you are using. Alternatively, you can over-power the florescent lights with flash or daylight (opening curtains in the daytime).

Shutter Speed

Most of the time, we want to freeze the action in a photograph with a fairly high shutter speed (125th of a second or faster). We want the subject to be crisp and sharp, the moment to be captured. Lenses between wide-angle and short telephoto can be hand held steady at these speeds, and it is enough to prevent blurring motion in subjects that are not moving fast. Short lenses can easily be hand held at a 60th of a second but usually not slower. Longer telephotos require more speed—I generally hand hold from 200mm to 300mm at 250th of a second or faster. Lenses longer than 300 require a tripod or other camera-steadying device, as does any lens when you start getting below a 60th of a second. If you are shooting with any lens at very slow speeds, use a cable release or the camera's self-timer to trigger the shutter. This prevents the slight jostle caused by pressing the shutter button with your finger.

But you may want to show motion in your

Tip

Practice motion photography at home before you leave. Go to an amusement park with rides, a race track, or even a nearby highway. You don't want to waste precious time on your trip learning.

Freeze, pan, blur. A fast shutter speed (top) makes it look as if the carousel is stopped even though it isn't. Panning at the same speed as the movement of photographer Cary Wolinsky (middle) keeps him sharp, and a slow shutter speed blurs everything else. In the bottom frame, the camera was held still and everything on the carousel was blurred.

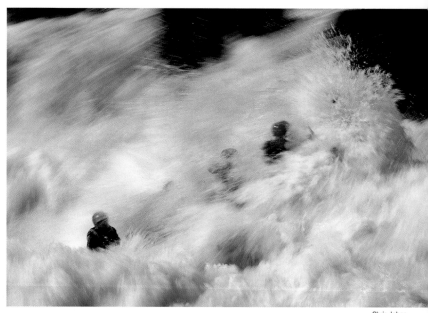

Chris Johns

A medium-slow shutter speed blurs the rapidly moving water a lot, the rafters a little, and convincingly conveys the violent force of the rapids. Always think about your subjects and how changing shutter speeds can affect your images.

photograph—a race car zooming down a track and shot at 2,000th of a second will look like it is standing still; your picture will not convey the sense of speed you were after. Use a slower shutter speed and pan with the car as it races past. This will render the car fairly sharp and the crowd behind as a blur. Alternatively, use a slower shutter speed but hold the camera still and let the car pass through the frame. This will show the car as a blur and show the crowd in sharp focus. How much the car blurs depends on the shutter speed: too fast, and the car may be frozen; too slow, and the car may become an unidentifiable blur of color or even invisible.

Panning can take a bit of practice, especially because you cannot see anything at the moment you make the exposure if you are using an SLR camera—the mirror pops up out of the way so light can get to the film. This temporarily blackens the viewfinder.

To pan, first figure out where it is you want the

camera to be pointing when you make the exposure. Position yourself so that you are comfortable facing there, exactly as if you were about to shoot. Focus the lens so that the subject will be sharp when it is in that position. Then, looking through the viewfinder, pivot back along the line your subject will be moving—but don't move your feet, just twist your body. It's much more natural and fluid to return to a comfortable position than it is to begin in one.

When your subject enters your frame, follow along with it until you reach the spot you have predetermined and press the shutter button. But don't stop panning. Even though you can't see anything, continue the motion until after the exposure is finished—this will help ensure that the subject doesn't zoom out of the frame.

Letting a moving subject blur in the frame is pretty easy. Simply frame your shot, wait for the subject, hold the camera steady, and shoot. The tricky part is figuring out what shutter speed to use. If it is a fast-moving subject such as a race car, the shutter speed can be pretty fast and it will still blur. If the subject is a person running, you'll need a moderately slow one. If the person is walking, the shutter speed will have to be quite slow to show any motion.

Try photographing cars on a highway near your home using freeze, pan, and blur at different shutter speeds to see how they work. Always remember the effect that changing shutter speeds has on the size of the aperture and what that means about depth of field in your image.

There are other times when you may purposely choose to blur an image, either by letting things in the scene move or by moving the camera while the shutter is open. If you are shooting a friend in a crowd, for example, you might have him stand very still, use a longish shutter speed, and let the crowd seem to wash in a slight blur around him. Blurring can be very effective if you are trying to create an

Tip

When you are on a trip, make an effort to get ahead of your companions so you can photograph them in the environment. Go in the first raft, on the first bus, or whatever, and shoot back.

impressionistic image or when used in combination with an electronic flash, something we will discuss in the next chapter.

Whatever shutter speed you choose, think of what you are trying to say and what you want the image to look like. Use the speed that is appropriate, always keeping in mind the effect it has on aperture, and therefore depth of field: Each doubling of the shutter speed means increasing the aperture by one f-stop, and therefore less depth of field.

Protecting Your Gear

Cameras and lenses are mechanical and electronic devices. Lenses are made of glass. Both can be harmed by water, sand, dust, and jolts. Do your best at all times to protect them.

There are all sorts of accessories you can buy to protect your gear, but there are also some simple homemade solutions. If you're traveling and it's raining or snowing, simply take the plastic shower cap from the hotel bathroom, wrap it around your camera, poke a hole in the back for the viewfinder, and voilà: camera raincoat. When you find yourself in very dusty or sandy conditions, keep your cameras and lenses in sealable plastic bags. I carry a box of them whenever I go on assignment. Never open the camera back or change film or digital cards when there's lots of sand or dust in the air. Find shelter somewhere, or wait.

Your camera bag should be large enough to accommodate the gear you use most frequently, but not so big that it is heavy and cumbersome. Most have compartments for bodies and lenses that are padded enough for normal usage. But if you are traveling over very rough roads, it's probably best to hold the camera bag in your lap to cushion it. One good whack can destroy a camera or lens, and in remote or even semiremote areas it can be impossible to get things fixed or replaced.

Tip

Always try to keep film out of direct sunlight if it is hot, and keep digital cards in protective cases when they are not in your camera. Heat is the enemy of film, dust and grit the enemy of cards.

When traveling where it's really hot, remember that heat can adversely affect film. Try to keep it as cool as you can—never leave it in a parked car or in a case directly in the sun. Always look for shade. Keep it in a cooler if you can. Otherwise, keep a wet towel draped over the case with the film. Evaporation from the towel will keep the case cool. As the towel dries out during the day, rewet it.

In really humid conditions, keep silica gel in an airtight case with your cameras and lenses. You don't want fungus growing on and etching into the glass. If you don't have a case, use those handy plastic bags. The silica gel—a bunch of little crystals—absorbs moisture. Some types contain a color indicator that turns pink when saturated with moisture, so you can easily tell when it's not doing its job anymore. To dry it out, put the crystals in a frying pan over a fire, shaking continually the way you shook popcorn in the days before microwaves. When it turns blue, it's dried out. Put the crystals in small cotton bags that you can tie and replace in the case or plastic bag.

Air-conditioned rooms can also present a bit of a problem in humid climes. Everything will fog up when you go outside into the heat and humidity, and it can take quite a while for the temperatures of your gear and the air to equalize. You may want to put your stuff outside well before you leave.

Cold presents its own challenges. Severe cold is hard on batteries, the oil that lubricates cameras, and film—I've had film leaders become so brittle they snapped off. Try to keep your gear reasonably warm as much as you can. Keep your camera inside your jacket so it can be warmed by your body heat, and always protect it as best you can from snow, sleet, and the like. Batteries don't last long in severe cold, so take plenty. To keep condensation from forming when you get back to the lodge, put your camera in a plastic bag while still outside, and let it warm up before removing it.

FOLLOWING PAGES: Always protect your gear from rain, snow, spray, or other moisture. Notice how the photographer silhouetted the subjects against the bright part of the image underneath the rainbow. Always move around and look for the most telling composition.

James L. Stanfield

SARAH LEEN
Engaging the Subject

Jesus Lopez

As a FINE ARTS MAJOR at the University of Missouri, Sarah Leen had to make some photographs to learn about photo transfers for a printmaking class.

"I borrowed my dad's old Kodak camera and tried making some pictures," Leen says, "but I didn't have any idea what I was doing."

It did pique her interest, though. She enrolled in the art department's new photography class, and by the time she graduated was more interested in photography than the other fine arts.

"I loved photography, but I had no useful photo skills," Leen explains. "We studied art photography, alternate processes—nothing practical that I could get a job with. My roommate worked at the *Columbia Daily Tribune*, which had a great photo staff at the time, and I started hanging around with them—a great way to learn about photography in the real world. I went to an NPPA Flying Short Course and was very inspired by Eddie Adams. He challenged the audience, 'How badly do you want it?' referring to a career in photojournalism. It made me want to learn more, so I decided to go back to school, to the University of Missouri Journalism School. That's when I really fell in love with photojournalism.

Sarah Leen (left) has an eye for capturing evocative images of a wide variety of subjects: natural history, landscapes, people, and conceptual themes

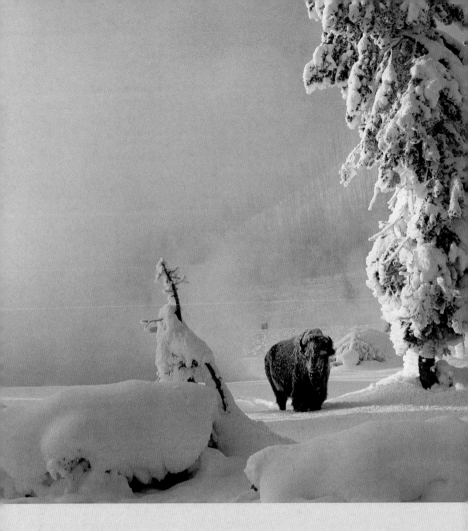

like the end of cheap oil. The success of her image of the buffalo in Yellowstone National Park (above) depends on the mood created.

"While at Missouri, I won the College Photographer of the Year contest, which got me an internship at National Geographic. That's when I started shooting color. My first stuff was awful. They even called me in and said, 'You've obviously never shot color before, have you?' It was a pretty steep learning curve."

As an intern, Leen handled general one-shot assignments around headquarters, worked on projects for the Book Division, and shot her first magazine story, "Return to Uganda," published in

1980. But she and Robert E. Gilka, Geographic's director of photography, both thought she needed to hone her skills, so she went off to shoot for newspapers for the next few years. While at the *Philadelphia Inquirer,* Leen freelanced for *People, Fortune, Forbes,* and other magazines.

"The whole time, I really wanted to get back to Geographic, so I started bombarding them with story proposals. Finally, in 1988 they assigned me to a story about the U.S.-Canada border. I quit the *Inquirer* and have been shooting freelance stories for the Geographic and others ever since."

Those stories have taken Leen to frozen Siberia, tropical Africa, and dozens of other places around the globe. Asked how she approaches assignments in such wildly diverse places, Leen replies:

"The first thing I do is research, endless research. I try to become an expert on the place or topic. I read all I can find, look at magazines and photo books. But I tell you, life's a lot easier since the Internet. The amount of information out there, and the easy access to it, is astounding. The Internet makes it much faster to learn about the place or subject, find out about situations, whom to call and talk to.

"Research is important because it helps you develop the theme—find the main topics within the subject, what needs to be covered. You start to build a story arc so you make sure you don't miss anything major. For some stories—country stories, for example—you have to know what the political situation is, the economy, ethnic groups, religion, significant days in the year when something might be happening. What's the place about? In stories like that, anything is fair game. Other stories are topical, like the ones I've done about oil, skin, and other more conceptual subjects. In those, the pictures are more

Sailboats at Mystic Seaport in Connecticut cast reflections in the perfectly still water of a foggy early morning. The photograph would not work nearly as well without the reflections. Glasslike water is almost always found very early, as is fog. Get out early.

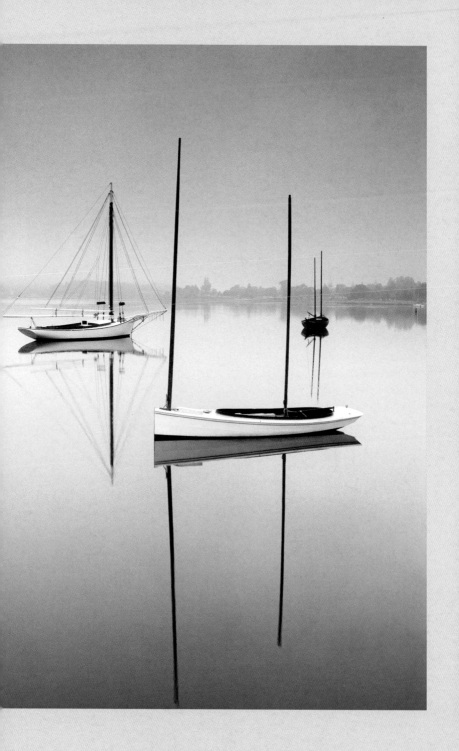

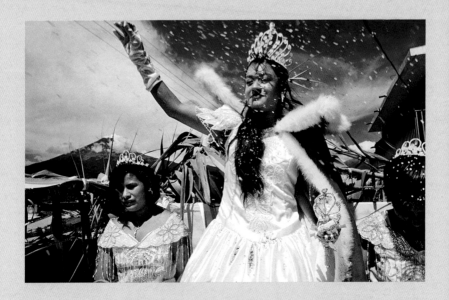

For this image of the queen of a local Mexican Independence Day parade, Leen chose a shutter speed that was fast enough to freeze the women but slow enough to cause the thrown confetti to blur slightly, giving us a vivid sense of its motion. Always think about appropriate shutter speeds.

specific—not everything is fair game.

"But having a wide-open subject is a double-edged sword. It can be overwhelming. Good research gives you a plan, a way to deal with the mass of information and a way to organize your time—it's a way to tell yourself that you know what you're doing. You have a plan and a goal.

"You must be willing to ditch the plan, though. The plan gets you going somewhere, but you might see something wonderful along the way. It's the bird in hand, and serendipity is often where the best images come from. The plan gets you out there and helps you understand what it is you are seeing. If you're flexible and willing to go with the flow, you get a nice mix of planned and serendipitous photographs that is the best possible combination.

"What I like best are stories that carry you back and forth between people and nature. Landscape work is so peaceful and quiet—looking closely at natural beauty and expression, just wandering around in nature. Landscapes are all

about light—it animates the scenes, conveys the mood. There are few things more serenely inspiring than watching a bit of the world change character as the day's light passes over it. But after a while I get lonely, and love going back to people.

"When I'm working with people, I like small, fixed focal length lenses rather than big, fat zooms. Just my little camera and me—it makes me feel that I can move through a situation and people don't notice me, or if they do, they soon forget about my presence and get on with their lives.

"And that's my favorite place to photograph— smack dab in the middle, elbow to elbow, accepted, and working from the inside."

That intimacy shows in her pictures.

Leen's Photo Tips

■ Wear good shoes. I am very big on footwear. Open-toed sandals with little heels aren't very appropriate for most photographic work. You don't want to be hindered by not being able to walk to where you need to get because your feet are too exposed or your shoes are not durable enough.

■ Learning even a little of a local language is a great icebreaker. People really appreciate it, and it's fun. If you do that, you're immediately separated from the herd, treated differently from the ordinary tourist. That enables you to get closer to your subjects and get better images.

■ When in Rome... Be sensitive to the local culture. It's easy to dress in a way that won't offend, and doing so shows your respect for people. It's a great way to spread goodwill. As you go deeper into a culture, you learn more intricate customs that enrich both your photographs and yourself.

■ Carry a compass. It's really handy for figuring out how the sun will strike subjects at different times of day. It also helps if you get lost.

■ If you find a spot you really want to photograph and it's far away from any town or motel, sleep in the car. It beats getting up at 3 a.m. and driving there.

■ Drink lots of water; take lots of bottled water if you're somewhere you can't get water or don't want to drink what there is. Guard your health— you can't make photographs if you're sick.

WHEN YOU'RE TRAVELING, you probably don't want to be burdened with several cases of lights, cords, light stands, soft boxes, reflectors, diffusers, and other lighting gear. In order to stay highly mobile and able to capture serendipitous events, you need to be able to take advantage of whatever available light any situation offers.

Using Available Light

Most of the time, we find ourselves shooting in pretty decent light. It may not be perfect, or all that we could ask for, but there's generally enough daylight to make decent images. One important part of the research you should do before you travel is to determine what the weather will be like at your destination while you are there. Unless you want a lot of pictures of rain, for example, you might not want to travel to India during the monsoon season. And once you arrive, pay close attention to the quality of the light. Sunlight actually looks a bit different in some places. And always pay attention to the basic rule that low-angled sunlight is warmer, casts softer shadows, and is generally more pleasing than the harsh light of midday. (Unless, of course, you want the harsh light to convey a certain mood or idea.)

However, we often find ourselves in situations—deep in a forest, inside a building, after sunset or before dawn—where there's very little ambient light and what there is may be dull and

Sam Abell

uninteresting. Your lens will open up only so far—at some point you reach the maximum aperture. You can hand-hold a camera steady only down to a 60th of a second, a 30th if you are quite stable. Below a 60th, subjects in the frame—if they are moving at all—will start to blur in any case.

One way to give yourself more flexibility is to use a faster film, push the film you have to a higher ISO, or increase the ISO rating on your digital camera. But remember that the higher the ISO, the grainier the image will be. And

Using only ambient light and the glow of a campfire, the photographer captured this peaceful scene. A slow shutter speed allowed the foreground man's face to be illuminated and the sparks to create trails. Never put your camera away when it starts to get dark.

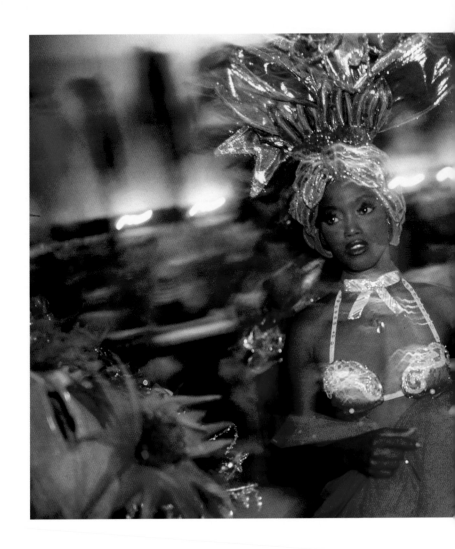

keep in mind that films, too, have their limits.

Look for any source of light in the scene—it might be a table lamp, a shaft of sunlight, or a campfire. If your main subject is near enough to the light, you may be able to get a decent exposure of at least the face. If it fits with the mood you are trying to convey, there is nothing wrong with letting the rest of the frame fall off into darkness. In fact, it can be quite effective.

David Alan Harvey

A slow shutter speed allows enough time for the ambient light in this Havana night-club to illuminate the background. Fill flash properly exposes and freezes the dancer. Don't be afraid to use slow shutter speeds.

Adding to Available Light

You may find that there just isn't enough light to capture what you want to say, but you want to keep the look and feel of the ambient light. Using an electronic flash at full power will overpower low ambient light, cast harsh shadows, and look exactly like what it is—a harshly lit scene. This is appropriate for some photographs and may be what you

want. If it is not, however, you should use fill flash.

Fill flash is a way to add just enough light to bring out the details and colors in a subject or scene without destroying the ambient light that may be one of your image's most interesting parts. When properly done, it is almost impossible to tell that a flash was even used. With modern cameras

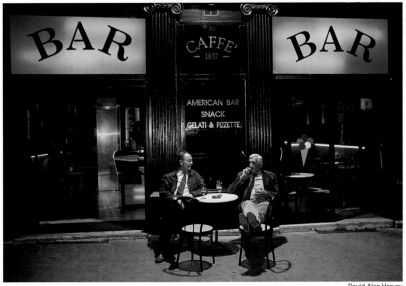

David Alan Harvey

and electronic flash units, it is a fairly easy technique but does require some practice to get the look you want, and you need to use a flash with adjustable output.

Set the shutter speed and f-stop on your camera to properly expose or slightly underexpose the room or other low-lit place you are photographing. Then set the flash unit to lower its light output. This can be anywhere from one to two f-stops, depending on how you want the image to look, how close you are to the main subject, and how reflective it is. If a person's face is very close, you may want to go to two stops under or even more. Because the camera and flash communicate with

each other, the output of light is automatically controlled; if you've set the exposure on the camera for f/5.6 and set the flash to reduce its output by one stop, it will put out light for f/8. Read the owner's manual for your electronic flash to find out how to adjust the output on your model.

This technique is also useful if you find yourself shooting in very dull or very harsh light. In flat, dull light, the addition of fill flash brings out colors and details that normal exposure in such light would not reveal. In harsh light, the fill flash will do just what the term implies—it will moderately fill in the deep shadows in people's eye sockets, under their noses, and so on that are created by a high sun. How much they are filled in depends on how much light you set the flash to put out. The only way to learn about fill flash is to practice. Try different situations, different distances from your main subject, different kinds of subjects (highly reflective and highly absorbent), and different amounts of light output.

Remember that at very slow shutter speeds things in the frame may be blurred either from their own motion or from camera shake. You can use this to your advantage by getting images in which there is some blur but the subject is frozen by light from the flash. If the flash is set on front curtain (the flash goes off as soon as the shutter is opened) the freeze will be at the beginning, and any motion will be recorded from then until the shutter closes. A rear curtain setting gives you the opposite—motion is frozen at the end. As with blurring in daylight, various shutter speeds produce various amounts of blurring, from slight to unrecognizable. Mastering this technique requires lots of experimentation, but the results can truly be stunning. Try it out with various combinations of shutter speed and light output, and different kinds of subjects, until you get comfortable with it.

If you are using a digital camera, you can see

Store signs and interior lights are often very colorful when photographed on daylight film or with "normal" or "automatic" white balance. In the image at left, the streetlight cast white light, which made the two men at the table stand out. Always think about the quality of light in the frame.

the results right away and can easily experiment with several different combinations. Professional photographers often carry digital cameras to do lighting checks on location. When they find what works, they use the same settings to get their exposure on film.

You can also use reflectors to add light. If you are in a hut that is quite dark, put a reflector (it can be a white sheet, a piece of white construction paper, or anything highly reflective) outside in the sun to reflect light into the interior. If you are photographing outside in the middle of the day, use a reflector to bounce light onto your subject to soften the shadows. Compact camping blankets with a silvery side are quite handy for reflecting and easy to carry around. I've even used a white shirt.

Odd Lights

Monuments and buildings often look their best not in the plain light of day but in the evening when their lights are on and the sky is alive with colors. But they are often lit by floodlights, which can have color qualities all over the spectrum. The same can be true inside places lit with fluorescent lamps—the bulbs can have widely different color temperatures.

If you are shooting floodlit structures with a digital camera, try different white balances until you get the look you like best. If you're using film, you can try both daylight and tungsten-balanced ones or color-correcting filters, though you will have to determine the cast with a color temperature meter to know which to use. If you are planning to scan the image and work on a digital file, you may be able to correct the color balance later. Whatever you do, make several different exposures—floodlit buildings can easily fool in-camera meters depending on what color they are, how much of them is lit, etc. Bracket to be sure. And

> **Tip**
>
> Always bracket exposures in tricky lighting situations. A streetlight or car headlights can fool the in-camera meter into underexposing; a black object or heavy shadow can fool it into overexposing. A good rule of thumb is to bracket one stop over and one stop under, both in 1/3 stop increments.

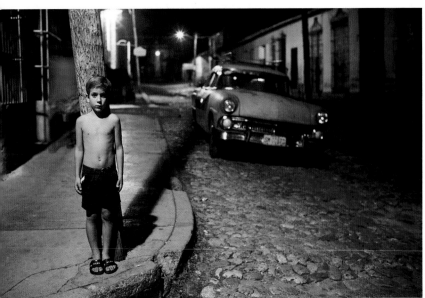

David Alan Harvey

use a tripod or other camera support—you will probably be using quite long shutter speeds.

The procedure is pretty much the same in rooms lit by fluorescent lamps. There are filters made to correct different types of lamps, but chances are there may be several different ones in any one place. You can use flash or fill flash to overpower the fluorescent lamps, but areas away from the flash (such as the ceiling or distant walls) will still reflect the ambient light. As we discussed in the section about color rendition, often the best solution is to work in close using fill flash and minimizing the area rendered by the fluorescent lamps.

The important thing is to get the look you want in your images. Don't think that every photograph has to have perfectly natural color rendition. The quality of the light, like everything else, should fit the idea of the picture. If you are making an image that you want to express the humdrum monotony of cubicle existence, for example, the green cast of a fluorescent-lit floor full of them may work perfectly.

Streetlights and other outdoor lights can vary widely in color temperature, like the mercury vapor lights on this street in Trinidad, Cuba. In cases like this, you can use filters, change white balance, or use the odd color for effect.

WEATHER HAS PERHAPS more impact on our photographs than any other single factor. The vast majority of images are made outside, and we are dependent on the light that Mother Nature gives us. You can't do anything about the weather. If you are traveling at leisure, with no particular schedule or able to easily adjust how much time you spend where, you can often hang around a place and hope to get the weather you want. An itinerary that doesn't allow for flexibility will compel you to make do with what you get. But never use bad weather as an excuse to not make photographs. Inclement weather can produce great pictures.

Shooting in Rain, Snow, and Other Inclement Weather

Cameras and lenses don't really like water, so when shooting in rain, snow, or somewhere with spray or mist, try to keep your gear dry. Use a commercially available camera cover, a towel draped over the camera, or the shower cap raincoat mentioned in Chapter Four. Keep the camera in your bag or inside your shirt or jacket when not shooting, and wipe off moisture as often as you can. Water on a lens can cause blurry areas on the image, and water can damage the mechanical and electronic workings inside. Salt water is particularly corrosive, so get it off your equipment as quickly as you can.

A fast shutter speed will freeze falling rain or snow. A slow one will show the lines of it falling.

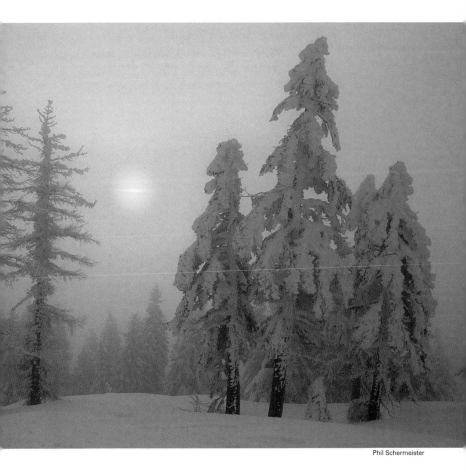

Phil Schermeister

Think about the background: Falling water is hard to see against a light background, easy to see against dark. Think of the effect you want your picture to have. If the precipitation is unimportant to your image, you may want to use a fast shutter speed to minimize and see through it. If the rain or snow is important, you may want the masking effect of a slower speed. If you can't find a background that really shows up the rain or snow, look for other ways to communicate it—umbrellas, wet people, the splash of raindrops, etc.

If you are shooting on snow, be aware that a lot of white in the viewfinder will fool the in-camera

The preponderance of snow and the hazy sun in this image would have fooled the in-camera meter into underexposing, making the image dark and the details in the trees lost. In situations like this, take a reading off a gray card and bracket to be sure.

meter into underexposing. It will want to make all the snow neutral gray. Take a reading off a neutral gray-toned surface and either set that exposure in manual mode or, if you are shooting in one of the automatic modes, keep the shutter button halfway depressed to hold the exposure while you frame the shot. (Your camera may have a different way of holding exposure, so check your owner's manual.) Many cameras allow you to compensate by setting the camera to automatically overexpose or underexpose. For snow you may need to set the overexposure by as much as two f-stops. If you are shooting a lot in a situation like this, it's worth setting the camera to overexpose so you don't have to think about compensating for each frame and you can shoot quickly. Just don't forget to readjust when you move to another situation. If your camera does not allow setting for overexposure or underexposure, you can change the ISO rating for the film and so fool the camera into it. If you are shooting ISO 100 film but want to overexpose by one stop, set the ISO rating at 50. If you wanted to underexpose by one stop, you would set it at 200.

Making photographs in fog or mist can be very tricky because they vary so widely in density, from quite light to fog you can barely see through. This is one area where the quality of your lenses really matters. Don't assume that because you can see something through the fog with your eyes the lens will be able to see it too. The human eye is a remarkably sensitive organ. High-quality lenses, made with the very best glass, will pick up details in foggy scenes that poor-quality ones will not. If you like to shoot scenes such as this, or know you will be traveling to areas where fog is common, it is probably worth investing in top-of-the-line lenses.

Be careful using electronic flash in mist and fog. If it is so thick that you have trouble seeing

William Albert Allard

through it, it's probably too dense for the light to penetrate. Light from the flash will bounce off the suspended moisture, and you will end up with nothing more than a picture of brightly lit fog.

As always, think about what you want your pictures to say and how you can use different types of weather to say different things about your subject. A picture of a beach on a bright, sunny summer afternoon when it's crowded with people says something quite different from a shot of the same beach on a stormy day when it is empty. Same scene, different weather, different feeling. Always look for visual elements that tell the story: A photograph of a storm should include something—bending trees, stuff flying through the air—that says "storm." How does different weather affect the place and the people who live there, and how can you show it?

Above all, don't use inclement weather as an excuse to stay in the hotel and read a book. It's not a hindrance, but an asset you can use.

Rain and sunlight bathe a Parisian café in warm light. Notice that the photographer made this image from underneath an awning, keeping rain off his camera (and himself). The slow shutter speed blurred the raindrops and the people in the frame.

Conveying the Season

A telephoto lens allowed the photographer to isolate part of a barn in Vermont, making it a graphic element against the riot of fall foliage behind.

Each season has its own unique look and feel, and these express themselves differently in different locations. Fall looks different in the mountains than it does in the desert. Rainy seasons in the jungle aren't the same as on the plains. And fall in the Grand Tetons is not the same as fall in the Alps.

Think about how the season expresses itself in the place you are visiting. It may even be the season that caused you to go to the place—New England in the fall, Aspen in winter, etc. Your pictures should show how you feel about the place at that time of year. Seasons don't apply just to landscapes, of course. Cities and towns are also affected. They and the people who live there take on various looks

Michael S. Yamashita

FOLLOWING PAGES: Sunlight bursting through storm clouds cast golden light on Mount Rundle in Alberta, Canada. Photographs like this are the result of patience and more patience, waiting for the conditions to come together. Notice how much of the frame is dark; the in-camera meter would have been fooled into overexposing this frame.

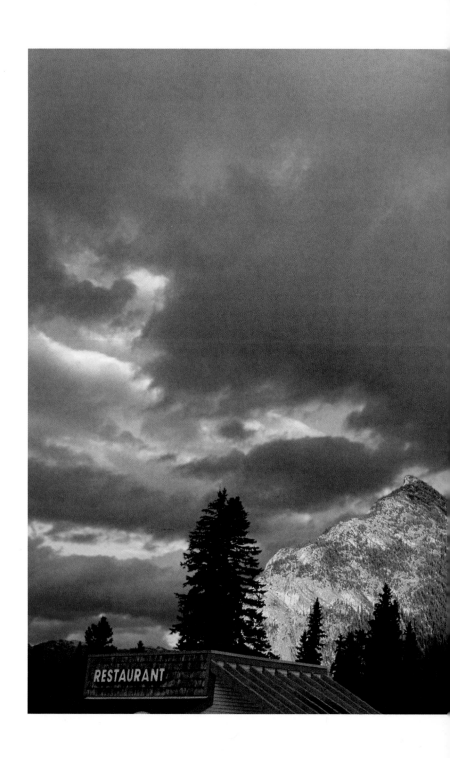

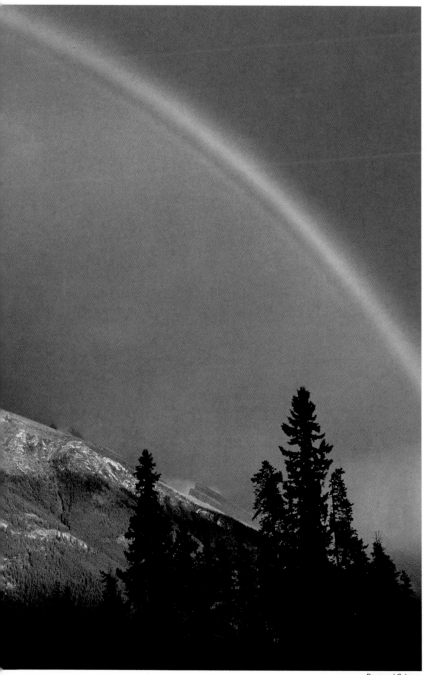

Raymond Gehman

Sisse Brimberg

How better to convey the warmth of spring-time sunshine than by showing people basking in it? The wide-angle lens allows us to see the row of baskers as well as enough of the park to get a feeling for it.

at different times of year, and may have festivals or celebrations that express them. Do some research before you go to find out if there are any special events. Wherever you are shooting, don't just look for the big picture. Details—icicles dangling from a bough, colorful leaves floating in a stream, feet in flip-flops—can say as much about a place or more than a wide shot can.

In temperate climates, winter means looking for ways to say "cold." It might be the way people are bundled up, steam rising from a grate, birds huddled on a wire, dormant plants, or whatever. Remember what we said in the previous chapter about shooting where there's lots of snow—be careful not to underexpose. If you are shooting people skiing or ice-skating, think about using some of the ways to show motion that we talked about in Chapter Four. If you are photographing a mountain, think about its quality. Do you see it as

majestic or threatening? What happens to plants, people, streets, and buildings during winter that is different from other times of year? Look for ways to show it.

The same applies to spring, summer, fall, rainy season and dry. In the spring and early rainy season, things come to life. Summer is hot, but we also tend to think of it as a relaxed time of year when the livin' is easy. Fall is energetic and colorful. Think hard about how the particular qualities of each season are expressed in the people and places you are photographing, and then find ways to visualize them. Look at photographic books not just of the place you are visiting, but also of seasonal images to see how others have communicated seasonality. Is there any prose or poetry written about what the seasons are like in that place? What is the locally expressed essence of the season? How can you get that on film or card?

Conveying Mood

Most good photographs convey information, idea, and emotion. Viewers look at and take in the subject, of course. But they also instinctively pick up on the composition, color tones, harshness or subtlety of light, people's expressions, intimacy or distance—all sorts of clues to inform their brains with ideas and their hearts with emotions. A picture of a happy child is nice, cute even. But how much more effective, and how much longer the image will linger in our minds, if "happy" is communicated by other elements of the image as well. A village that is nestled in a valley needs to be shown as nestling.

If you are staying in a place for a while, think about what sort of weather would best convey the mood of the place you want to express and then wait for it. If bright, cheery, blue-sky sunlight best suits the scene, wait for a sunny day. If dark, threatening skies are more appropriate, wait for those.

Tip

Don't be shy about photographing people. The way they are dressed and the ways they behave can help your images convey both the look and feeling of different seasons in different places.

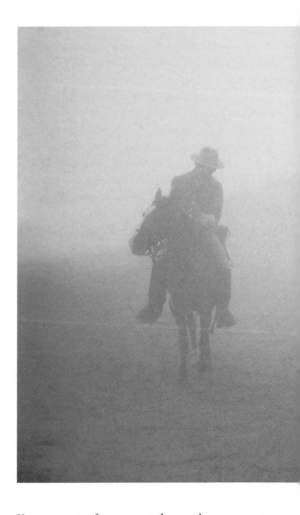

Light fog allows the camera to see just enough of these Civil War reenactors to see their costumes, but softens the scene enough to convey the sense of history. Use fog to enhance the feeling of appropriate subjects.

You may not, of course, get the weather you want, but if you have time and are patient you may well be rewarded. I find it helpful, when I'm spending time in a place, to make a list of things to shoot in different sorts of weather—when it's rainy I shoot these; when it's sunny, those. Different kinds of light and weather connote different moods. Use adjectives to figure out what to shoot when— somber, cheery, pensive, majestic. Match the place with a concept, match the concept with weather.

A good exercise is to make pictures of some-

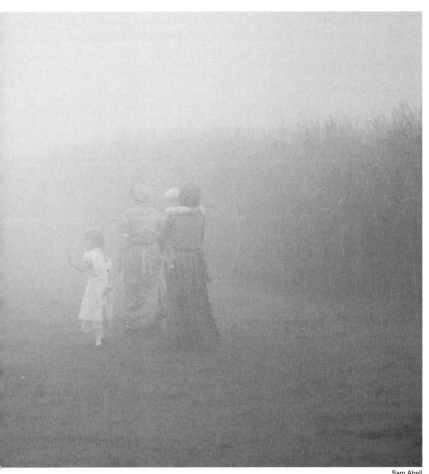

Sam Abell

thing near enough to your home to be visited easily. It could be your house, a nearby park, or the scene out your office window. Photograph it at different times of day, in different weather, and in different seasons. Then get all the pictures together and look at how dramatically different the images are. Think about how different kinds of light and weather affected the scene—not just the look, but the feel, too. Try to remember these differences, so when you're traveling you'll recognize the conditions you're looking for.

ON SUNNY DAYS, the most pleasing light for outdoor photography is early in the morning and late in the afternoon. The light is at a low angle and is striking subjects from the side, so shadows are long and give contour or "modeling," which helps give the illusion of depth to the images. Low sunlight is also more flattering to most subjects. It contains more of the red or long end of the spectrum, and we perceive golden light as warm and pleasing. Don't miss the "magic hours" just after sunrise and before sunset.

Early and late are good for other reasons too. In tropical countries, people tend to be most active when it is cool, so markets, street scenes, and the like may be most lively then. The same is true in temperate climates: Trucks and deliverymen are making their rounds, fish and vegetable markets are alive with trade, people rush about on their way to work. Wildlife too: Many animals sleep during midday. Dew on the grass and mist in the valley don't last long once the sun is up. You have to be out there to catch them. But like any rule, this one was made to be broken. There are many situations when harsh midday light is appropriate. Again, think about your subject and what you are trying to say, then shoot in the light that fits.

Scout

Once you've arrived at your destination, keep your eyes open at all times. When you're in a bus or taxi, when you go out for coffee, while you're waiting to

Chris Johns

change money—always be on the lookout for picture opportunities. Go for long walks. Once you've dumped your stuff in the hotel, take a stroll. You don't have to be going anywhere, just looking. If you've flown a long way, you'll probably want to stretch your legs, and being out in the sun is the best way to get over jet lag—your body adjusts more quickly if it knows the position of the sun in the sky.

When you are out and about, always carry your camera in case you happen upon some wonderful scene. Serendipitous encounters are of primary

Late afternoon sun lights up cliffs reflected in the still water of the Missouri River in Montana. Landscape photographs often look best in the low light of early morning or late afternoon.

importance in travel photography and often where the best pictures arise. Always carry that essential notebook too. Look for things or places you think will yield interesting photographs. When you find them, consider what time of day would be best to shoot them. Let's say it's noon and you notice a beautiful facade on a building. Figure out what light you think it is best photographed in—do you want it in shade or sunlight, early or late? Then discern which direction it faces and decide when you need to be there. Look carefully. Are there buildings across the street that will cast shadows? Write down the location and the optimum time of day so you don't forget.

If you take a tour, you will be dependent on the tour guide's schedule, so look at these as scouting trips too. Bus and trolley tours are great ways to familiarize yourself with what a place has to offer, but you probably won't have the time or light to get great pictures. Make notes about what you want to photograph and when the light in those places will be best so you can go back at the right time of day.

Once you've done some scouting, sit down and make a schedule for yourself so you can maximize efficiency. Put all the early morning things together, and all the late afternoon ones. Then figure out which are close to each other so you can try to do two or three each morning and afternoon. Don't schedule too much—good photography takes time. You may have to wait for clouds to clear, for the market stalls to open, the streets to fill with people, or whatever.

Get Up Early, Stay Out Late

Don't be lazy, either. In order to be somewhere at sunrise, you have to get up well before and get there. If you're traveling on your own or with friends, you can set your own timetable. If you're on a tour, scheduled excursions generally don't leave a hotel or cruise ship until after breakfast, and by

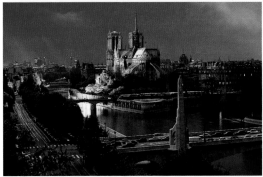

James L. Stanfield (both)

Two identical frames of Notre Dame in Paris convey very different feelings. The lower frame uses the soft light of evening and the lights on the cathedral and other city lights to create a more engaging image. The slow shutter speed is revealed by the streaked car lights in the street at left.

then the magic hour is past. Get up and out early, then come back to join the tour. It's much more interesting to eat breakfast in a local café than in the hotel—you'll get a better feel for the place and may find pictures while you're eating. The food's probably better, too—it will certainly be more interesting and will add to your understanding of the place. If you need to take an early morning taxi, make sure you've made arrangements for one the night before. If you can't function without coffee, fill a thermos with some before you go to bed—it

will still be hot in the morning. Or carry a heating coil and instant coffee so you can quickly make some in the morning. But don't come up with excuses. There's nothing worse than wishing you'd been somewhere in better light when you know you could have been. There's only one dawn each day.

Afternoons are often about waiting. Let's say you've found a place you want to photograph. You've determined that late afternoon sunlight would be best, but it's only three o'clock and the sun is still high. Don't just say, "This will do." Don't be in a rush to get back and take a shower or eat dinner. Let your friends or the tour bus leave without you. Use the two or three hours to scout for other locations. Or just hang out. Sit on a bench, at a café, or somewhere and absorb the ambience of the place. It will probably give you ideas for other pictures. Read the local newspaper to find out what's going on. Hanging out also allows for the serendipitous encounters with local people you just can't have when you are part of a group.

Also watch how the changing light affects the scene as the sun gets lower. And when you think you've got it, wait some more. As the sun begins to set, you will start to get soft light and colors in the sky that weren't there before. The scene will probably keep getting better and better. The best images often come after you think you've already gotten the best one.

Shooting at Dawn, Dusk, and Night

When you get up early enough, you are rewarded with seeing, hearing, feeling, and perhaps even smelling places come to life. Birds begin to chirp, animals stir, flowers unfurl, people begin moving about. In the evenings you can partake of the shift from light to dark—nocturnal animals begin their routines, streetlights and building lights come on. The borders between day and night offer wonderful photographic opportunities.

There are three kinds of shooting around dawn and dusk: In the darkness or very faint light before the sun rises and after it sets; just before it rises or after it sets, when there's plenty of often quite colorful light in the sky; the sunrise or sunset itself.

Night and Faint Light

When shooting at night or in the very dim light of early dawn or late twilight, you will be using whatever ambient light there is plus lights in buildings, on streets, campfires, or some other man-made light. Ambient light can vary widely. If there's a full moon and you're shooting landscapes of snow or white sand, there'll be quite a bit, and it will increase rapidly as dawn nears (or decrease rapidly as twilight deepens). Such scenes should allow you to make an acceptable exposure at a long shutter speed. Be aware, though, that if the moon is in the frame, its orbital motion will cause it to blur at speeds slower than 1/4 second. Moonlight images of places with less reflective surfaces can require exposures several minutes long. Use a tripod or other camera support and a cable release or the camera's self-timer (unless you are shooting with the shutter speed set on bulb, in which case the self-timer won't work).

Exposures of cityscapes or other scenes with man-made lights vary widely depending on how much light there is in the frame, how intense they are, and how reflective other parts of the scenes are. Be careful metering, especially if there is one particularly bright spot in the frame—it might fool the meter. Cityscapes at night may look best when shot on cloudy nights, as the light from the city reflects off the clouds, giving you something other than a purely black background. If you're photographing friends sitting around a campfire at night, try using a remote-triggered flash placed behind the fire, covered with an orange gel so it looks natural, and

Tip

If you are without a tripod but want to shoot with a long shutter speed,set your camera on your camera bag, bundle up your jacket into a pillow, and use that—there is always something you can use for support.

St. Isaac's Cathedral in St. Petersburg, Russia, was photographed at dusk when the light in the sky and on the ground were in equilibrium, and faint enough to allow the lights on the trees, buildings, and cars to be visible.

pointed at your subjects but powered down so it doesn't overwhelm the firelight.

When you photograph at night—landscapes, street scenes, or whatever—always bracket exposures to be sure of getting a decent one. Use your meter as a guide, but expose two or three stops above and below in 1/3 stop increments. If you're shooting on a digital camera, you can check right away. If you're using film, you won't find out if it worked until you get home, but using up more film is a lot cheaper than going back.

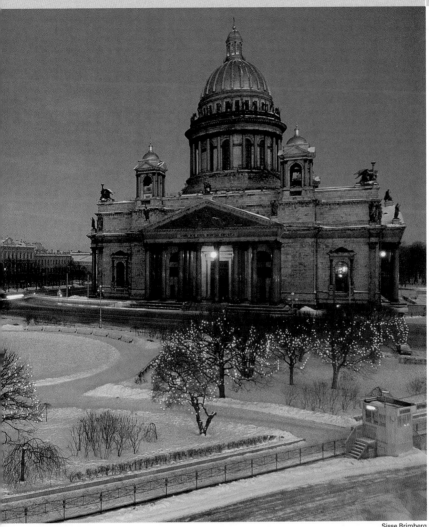

Sisse Brimberg

Before Dawn or After Sunset

You've scouted locations and decided that a particular one would make a great sunrise shot. You should have determined exactly where you want to be—the sun rises and gets hot pretty fast, so you won't have much time to change locations. You want to be there, all set up and ready, before the first light appears in the eastern sky.

As light grows in the east, the sky begins to take on color and the balance between man-made and

FOLLOWING PAGES:
By photographing this diner at night, using only the lights of the diner and nearby buildings, the photographer allows us to see inside. The blurred pedestrian shows the slow shutter speed.

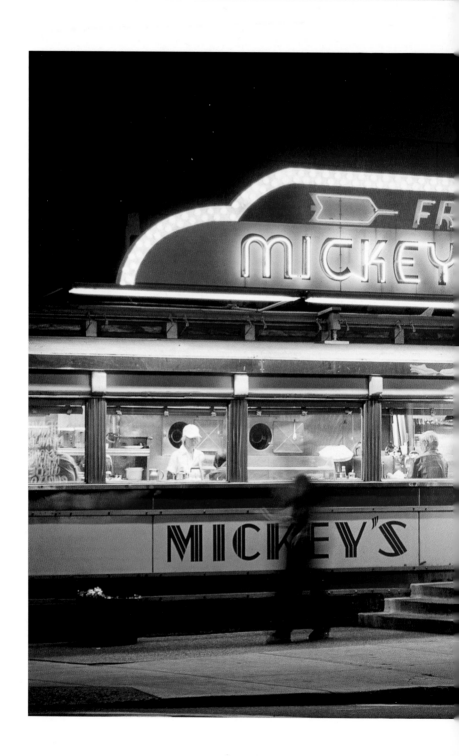

Gail Mooney

natural life shifts. There will be a moment when light on your earthbound subjects and in the sky reaches equilibrium and you can have both properly exposed. This moment does not last long. Soon the sky will be bright, and if you want to keep shooting toward the east, you will have to silhouette objects against the sky if you don't want it to be blown out. Silhouettes against a pre-dawn or post-sunset sky can be gorgeous—you may get an intense solid color or a speckled, multihued one. To make silhouettes, expose for the sky and let things against it go to black. Make sure that you expose properly and do not underexpose—the sky quickly gets brighter than neutral gray. If you want to get some detail in the silhouetted subject, open the aperture a little or use fill flash to throw some light on it. If you want to see the subject in full detail, use your flash at regular power.

All the above applies to shooting after sunset too, except that you will be dealing with falling rather than rising light. In both situations you have to work pretty quickly. The colors in the sky do not last long.

Sunrise and Sunset

You can photograph the sun itself only if it is masked by something—haze, clouds, or some object. The rising or setting sun on a clear day is just too hot—you end up with a picture of a bright ball. All those gorgeous sunsets we see are caused by haze or, unfortunately, smog.

If you are using a wide-angle or normal (50mm) lens, the sun will be a small element of the photograph. This may be what you want if the scene is beautifully lit and clouds are reflecting pink and orange colors. If you want the sun to be big, use a telephoto—the longer the lens, the bigger the sun. Look for subjects to silhouette against it or a part of the sky nearby. Be careful metering,

Tip

Never leave a camera sitting with the lens—especially a telephoto lens—pointed at the sun. The lens can act like a magnifying glass and burn a hole in the camera's curtain.

Jodi Cobb

as the sun and sky near it are usually hot. A good rule of thumb is to take a reading off the sky about 45 degrees away from the rising or setting sun.

As with silhouettes against a colorful sky, use fill flash to add a little light to subjects silhouetted against the sun if you want to show some detail. You can also use a reflector of some sort to bounce light onto it.

Don't be satisfied with just a nice picture of a rising or setting sun. It might be pretty, but the sun looks the same everywhere in the world. Look for elements you can include that say something about where you are. It might be a statue or skyline, a building that shows the particular architecture of the place, an indigenous tree, a person wearing distinctive dress. Whatever it is, think hard about how your image can reflect the place where it was made and stand out from other sunset shots. And don't get so carried away with how pretty everything looks that you forget about composition.

Use some distinctive feature of the place you are visiting as a silhouette against a rising or setting sun. The sun itself is too hot to photograph unless it is masked by haze or some object.

JIM RICHARDSON
Being Prepared

Kathryn M. Richardson

RURAL KANSAS WAS DARK at night—so dark that young Jim Richardson had no problems developing and printing pictures in the kitchen of his parents' farmhouse. His father had bought him an enlarger and out-of-date paper at a pawn shop, and Richardson happily watched pictures of his dog, the garden flowers, and still lifes of chess pieces emerge from the soup. He read *Popular Photography,* and remembers in particular an article about the photographer Fred Ward and all the equipment he had. He dreamed of one day having all those wonderful tools too.

Richardson left the farm to attend Kansas State University. He went to work for the college newspaper, and on the strength of his performance there got an internship at the *Topeka Capital Journal,* where he spent 11 years.

"Working at a newspaper is the best experience a young photographer can get," Richardson says, "At the *Journal* we did everything from take the pictures to layout and captions, for three or four stories a week. And you had to learn how to make decent images of just about anything.

"In those days, everybody wanted to do in-depth black-and-white photo essays. I wanted to

To capture this striking image of the Columbia Gorge, Jim Richardson (left) visited the exact same spot near Crown Point lookout ten mornings in a row—and had to be there by about 4:30 in the morning to be sure of not

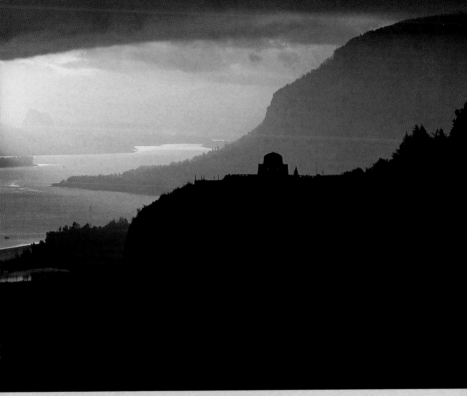

missing the light. His perseverance paid off and on the last day he got the great sunrise he was looking for. Scenes with high contrast within the frame make for tricky exposures: "It was tough to nail," Richardson says, "so I bracketed exposure—a lot."

document rural Kansas—my roots. I settled on the small town of Cuba, about 15 miles from the farm where I grew up. I had no idea at the time that it would be such a long commitment."

Thirty years, to be precise, and counting. Richardson's unobtrusive camera has watched people in the farming town of Cuba (population 231) grow up, go to school, get jobs, have children and grandchildren. It has seen the community ebb and flow, its farmers and merchants weather good times and bad. It is an unprecedented record of the kind of town we all want to believe lies at the heart of the American spirit.

Between regular trips to Cuba, Kansas,

Richardson continued to work at the *Capital Journal*, then went to the *Denver Post*. While there, he photographed a story about the flooding of the Great Salt Lake for NATIONAL GEOGRAPHIC, and when he left the *Post* in 1986, he became a regular freelance contributor to that and other magazines.

"My favorite stories are the cultural ones—I like to dig deep into the places I go, to get to know people in their element, living their lives. The 30 years I've spent photographing in Cuba, Kansas, have paid off in more than just a respect and love for that one community. It's helped me go other places in the world and understand everyday folks.

"It all depends on how you approach people. There's no way to get decent pictures of people unless they're comfortable and you're comfortable. People almost always know they are being photographed—they are aware. Either they let you into their lives or they don't. If you are decent and real, approach people with respect, and send a message that you are genuinely interested in them, the veil drops a bit and you get a chance to see life as it is, to capture something real."

Like all regular National Geographic contributors, Richardson is technically proficient and a good craftsman, but knows that the most difficult part of picture-making is not the f stops and shutter speeds.

"Gear matters, of course. And yet the finest table saw in the world is useless in the hands of someone who doesn't know what to do with it. Lots and lots of photographers have great equipment. Relatively few really think in depth about the subject—what to photograph and why, where to get the images to tell the tale, what mix there should be for the story.

"In some ways, travel stories are the most difficult because so much of the time it's 'run and gun'—you have a lot to cover and little time. It is essential to have the story concept in mind, to

Photographing daily life on a farm in North Dakota, Richardson was hanging around the barnyard in the evening, thinking work was about done. Then he noticed the boy at left bringing two puppies to show off, their mothers showing obvious concern. With no time to adjust exposure or focus, Richardson relied on auto modes to capture this striking image. The lesson? Never put your camera away.

A dull, gray dawn almost kept Richardson from going with these lobstermen off one of the Orkney Islands, but he figured he was up anyway, so he might as well. The clouds eventually thinned enough to allow for this dramatic and atmospheric image. Though the light was low, Richardson knew he needed a fast shutter speed to freeze the gulls in mid-flight.

understand what you are after. If you don't, you can easily be overwhelmed. You know you have to cover the fundamentals. The sense of place: the natural or urban landscape that shows the look of your subject. Then it's life within that environment: How do people make their livings? How do they enjoy their time off? What do they eat? What do people do after dark? Where are the young people? Where are the old ones?

"A lot of this comes from research, which I love. Research is half the fun. But in the end, it can only take you so far. You have to nose around on the ground. I've found that a great resource is the bulletin board in the local grocery store. You

can find out when the town band is giving a concert on the green, when the bell-ringers at the church will be practicing, when the book club meets, when there's a community cleanup day—all sorts of things that even the most thorough pre-arrival research would never uncover.

"Most of all, you have to be observant, sensitive, and culturally aware. Read as much of the literature of a place as you can; it gives you insight into how local people think. You may be trying to behave properly, but if you don't have at least a little understanding of the mores of a place, it's easy to be rude without knowing it. That will cost you in both photographic and human terms. Being in another culture, whether it's halfway around the world or just down the road, goes way beyond photography. You can't be someone who just takes people's picture and then goes away."

After 30 years, no one in Cuba, Kansas, would say that Jim Richardson is someone who just takes their picture and goes away.

Richardson's Photo Tips

- Get up early, stay out late. If you have to miss dinner, eat later. You can sleep at home. Always carry a flashlight. It helps you find your way around in the dark, find things in your camera bag, and can be used to light small objects for photographs.

- Don't be shy. If you are uncomfortable, your subjects will be too.

- Work situations over. Think of making pictures as you would of writing an essay—you go through several drafts and they keep getting better.

- Give yourself an assignment—it gives you an excuse for being there and making pictures. With an assignment, an idea, you have expectations that help you avoid just making a bunch of snapshots. Be available to serendipity. Inevitably the world is better at providing than we give it credit for.

- Be persistent. There is no magic formula for making good photographs, just grunt work. You may not have success every day—few people do—but when you do, it's worth all the effort.

WHEN TRAVELING, you're likely to encounter all sorts of situations and subjects. This requires being a bit of a jack-of-all-trades—you need to be able to photograph portraits, landscapes, and everything in between. A basic camera kit should be enough for most of the subjects listed here, but remember that if you are doing a specialized subject, you may need special equipment. When approaching any of these subjects, think hard about what ideas and feelings you want to communicate, and use (or break) some of the rules of composition, lighting, and so on that we have discussed.

Above all, work the situations over. Never be satisfied with your first view of a place or the first frame you snap. It's always possible—and usually likely—that you can come up with something better. Why else would painters make sketches? Get closer, then get closer still. Try different angles, different lenses. Wait for the light, wait for the crowd, wait for a bird to land on the tree branch. Never be in a hurry to get somewhere else. Tell yourself that nothing is more important than getting the best you can get out of the situation you are in. Once you've exhausted every possibility you can think of, you can start working on the next one.

Landscapes

Landscapes come in all forms—mountains, forests, plains, deserts, swamps, lakes, rivers, seacoasts. Each has its own characteristics, and individual sites within each category have their own

Frans Lanting

too. The Grand Tetons do not look like the Andes; the Nile River is different from the Mississippi.

Whatever kind of landscape you are shooting, think about what the essential qualities are—and not just the visual ones; think about how the place makes you feel, what kind of emotions it stirs in you. Then look for ways to get those qualities and feelings onto film. Is it a rocky, violently wave-washed coast or a bright sandy one? If it's the former, you want to show waves crashing against the shore, probably in stormy weather. Blue sky and

Landscapes do not always have to be vistas. In this image, the photographer allowed windblown wildflowers to blur into a riot of color by using a slow shutter speed.

sunlight are more appropriate for the latter—unless you want to show the desolation of a resort beach in winter.

Landscapes can be tricky because they tend to encompass so much. On plains and deserts there'll be a lot of wide-open space, in forests and swamps, a jumble of vegetation. Viewers need something to focus on. Make sure you have a point of interest—a lone farmhouse, a wind-patterned dune, a tree that's different from the rest. Use a leading line or some other device to draw attention on it. View the scene through both wide-angle and telephoto lenses. Scan around through the camera until you've found what works. And never be satisfied with your first encounter with a place. Climb a ridge, move upstream—change positions to find the optimum view.

If you are shooting waterfalls, remember that you can either freeze the water or have it become a milky blur by changing shutter speeds. Try using a polarizing filter to see if it increases the contrast between the water and the rocks over which it falls. When shooting water, also keep an eye out for reflections that can add to your image.

On beaches, deserts, and snow, your in-camera meter can easily be fooled into underexposing the scene. In deep forests and swamps it will tend to overexpose because of the preponderance of dark areas. Meter off something neutral gray, and bracket exposures.

Also look for the telling details. Sometimes an extreme close-up can say as much about a place as a wide shot. If you're shooting a story about the place, you will need both wide and tight shots to fully convey the look and feeling of your subject.

Cities and Towns

Like landscapes, each city and town has its own look and feel—a distinctive setting, architecture,

Wet pavement, rising steam, neon, and vehicle lights add atmosphere to this night shot of Broadway in New York City. Always get out after a rainfall to look for reflections and atmosphere.

Jodi Cobb

or skyline; a famous local site; a particular kind of food or dress. There's always at least one thing that is unique. When covering a town or city, even a small village, you need to do three basic things at a minimum: capture a sense of place, which is usually a wide shot that shows the setting, skyline, or other view that gives a feeling for the whole; landmarks that the place is famous for; the life of its inhabitants. For the cityscapes and wide shots, as well as for the landmarks, it's a good idea to check out the postcard racks in your hotel lobby or at kiosks. They will quickly give you an idea of where the best views are and what is considered well-known enough to warrant a postcard. We will talk about photographing buildings and monuments in a later section. Here we will concentrate on street shooting.

As I mentioned earlier, it's a good idea to get lost when you are in a strange town. Wander around just to get a feel for the place. Eat at local restaurants. Figure out what the place is about. Is it an important port with a busy waterfront? Is it a

Annie Griffiths Belt

Look for unusual ways to say something about the place you visit. In this image, the photographer combined two famous London features: a London taxicab and Westminster Abbey.

commercial center with lots of gleaming office buildings and people in suits? A decaying manufacturing town? Whatever it is, find ways to show the lifeblood of the town.

Street shooting is one of the hardest things for most of us to do. We are shy, uncomfortable with making pictures of people we don't know. This is natural, and in essence a good thing—we should all be aware of and sensitive to other people's feelings and customs. I will talk more about shooting strangers in a later section of this chapter. For now, just keep in mind that people are more important than photographs and that when you are traveling you are a guest in someone else's home, so you should act accordingly.

As you wander around, always keep your camera ready for serendipitous events. Have a lens on the camera that you think is appropriate to what you might run into, and if you are shooting in manual mode, set it in advance so you can shoot quickly. Don't have too much gear in your camera bag; it should be light enough to allow you to spend several hours toting it around.

When you find a scene—the view down a particular street or the facade of a building, for example—take up a position that you like, frame the image, and then wait. You might want a yellow taxi coming down the street, or someone to approach a sidewalk vendor. Maybe you would like to have a group of people leaving the building. Be patient. Wait for the elements you want to come together.

People add life to photographs just as they add life to their cities and towns. If you are shooting street scenes, think about how you want that particular street to look—empty or bustling. What is the street about? If it's a back alley, devoid of people might suit it. A shot of Trafalgar Square is probably better with a crowd. People add scale to images of buildings, statues, monuments, and the like. We would not know just how high Nelson's Column is unless we saw people wandering around its base.

But to truly show the life of a place, you need photographs that are a lot more intimate than simply showing crowds of people on city streets or using them to give scale to structures. Don't be afraid to engage people on the street. If you want a shot of that street vendor, you can make it from a distance with a telephoto or you can go near and use a wider lens. The closer shot will usually be much more intimate and telling than the long one. Walk up to him and start chatting. Tell her you are a foreigner visiting her country and how much you like it. If language is a problem, use sign language. Buy something. Tell the vendor that you would really like to make a photograph of him and his wares and ask if it's all right. Most people don't mind having their picture made if they are approached in a friendly and open manner. A lot do mind if they aren't. Remember that your success or failure in getting good people photographs is entirely up to you. It requires a couple of other little-discussed qualities that travel and editorial photographers are required to have: diplomacy and tact.

Tip

Always turn off your digital camera before removing or inserting the digital media. If the camera is on, you may destroy the card.

If it rains, get out at dusk or dawn and look for reflections of lights in the wet streets. If it snows or there's a storm, how does that affect the look of the city? Use the weather and time of day as you would with any other subject. Explore a city or town as you would a wilderness.

Monuments and Other Buildings

The stately Colosseum is surrounded by a whirl of lights in this long exposure at night. Famous and much photographed sites require extra thought to come up with something different.

When you are photographing buildings, statues, or other monuments, think about what they represent before you shoot. For example: There's a large statue of Vulcan outside Birmingham, Alabama. You could make a perfectly nice image of him standing on his hill on a sunny day, but such a picture would not say a lot about who Vulcan is. A photograph on a stormy evening, with perhaps lightning in the background, would. Cannons on a historic battlefield might look better in fog than in bright sunlight. Get the idea of the subject, then think of the weather, light, angle, etc. that best communicates it.

Be aware of the color of the building or monument. Many of them are white and will want to fool your meter. Since many of them are floodlit, think about using that light at dawn or dusk when there is color in the sky. Remember that artificial lights vary widely in color temperature, as we discussed in Chapter Five. Choose a film type or white balance that will give you the look you want.

When you are shooting a skyscraper or anything else that's tall, watch out for "keystoning." Often we stand near a building and photograph it with a wide-angle lens so we can get all of it or as much of it as possible into the frame. To do this, we tilt the camera upward so that the film plane is no longer parallel to the plane of the subject. The result is an image in which the lines of the building converge and it appears to be falling over backward. You can eliminate this by moving away from the building and using a longer lens, so that the film plane can remain

Winfield Parks

at or close to parallel. In some cases, of course, it's impossible to get far enough away—there's another building across the street. If you enjoy photographing architecture and want to make that one of your primary goals, you might want to invest in a perspective-control lens that allows you to shift the optics rather than the camera. There may also be times when you want to use the keystone effect.

Think about placement. If you are shooting a statue, look carefully at the background to make sure there's nothing that looks odd or will distract from the mood you're after. But that doesn't mean eliminating everything. If the statue is an important feature of a garden, you might want to include enough of the flowerbeds and so on to give the statue its proper context.

As with all other subjects, think hard about what the building, monument, or other subject

FOLLOWING PAGES: Seated Buddhist monks in their saffron robes lend scale and a touch of humanity to the carved faces and other features of a temple at Angkor Thom in Cambodia. People are an important element in monumental photography; they help us understand size.

Wilbur E. Garrett

represents and how you can use the tools of photography to convey that. What's the best light for this particular building or statue? If you are working in dim light, you might want to use fill flash to see detail in the statue and make it stand out. If the form of the statue is more important than the details, perhaps it would look best as a silhouette.

Tip

Hang out. Whether in a bar, a museum, on a street corner, or in the lobby of your hotel, let the images come to you. Never be without your camera.

Inside

As we mentioned in Chapter Five, light inside buildings can vary in color temperature. Incandescent bulbs produce a temperature much warmer than the sun, and will give a yellow/orange cast to daylight films. Use a tungsten film, a filter over the lens, or change the white balance on your digital camera to correct for proper color rendition. You may, of course, want the warm, homey cast if you are trying to communicate coziness. If you use a fill flash mixed with tungsten light, remember not to overpower the mood of the available light and use an orange filter over the flash head to warm up its light. Florescent lights vary widely in color temperature. If you know what type they are, and if they are all of the same type, you can correct with filters. Otherwise, use your flash. The backgrounds will probably stay greenish, but your subject will look normal.

If you are on a tour inside a building where the public is allowed, you may or may not be permitted to use electronic flash. Try to find out what the rules are beforehand. If you can't use your flash, carry a tripod or monopod so you can make long exposures. You might want to take the tour twice—once to scout and once to shoot.

A room can look markedly different at different times of day and in different weather. Determine which direction the windows face. Will there be shafts of sunlight streaming through them in the morning or afternoon? Does the room look best with those shafts, or would it be better to draw the

Using only window light, the photographer captured the atmosphere of a London pub (below). The ambient light inside City Hall in Helsinki, Finland, was enough to get a proper exposure and still reveal the spotlight on the art (bottom). Because everything in the frame is white, the photographer had to compensate exposure.

thin curtains and soften the light? If you want to photograph a person in the room, you can often use nothing more than the sunlight coming through the window, perhaps augmented by a reflector.

Think, think, think. What is the character of the room? How can I show that?

Jodi Cobb (both)

Wildlife

Serious wildlife photography is a specialized area that requires long lenses, blinds, stalking, and a lot of time. But if you are hiking in the wilderness or on safari, you should still be able to get some decent images of the animals that inhabit the area. On

Wildlife, whether big or small, usually requires a telephoto lens if you want to reveal any detail or character. All animals have "flight distances." If you get too close, they run away.

safari, you will probably be viewing the wildlife from a vehicle. Animals in most of the parks are quite habituated to cars, and you should be able to get fairly close. A 300mm lens (at least) is still a good idea if you want to get portraits. Don't be shy about telling your guide or driver what you want. They will want to show you as many different animals as possible because most people go on safari simply to see them. But good wildlife photography takes time. Many animals, especially the predators, spend goodly parts of every day sleeping. To get any decent behavioral shots, you have to be there, and ready, when they stir. When you find an animal you are interested in, tell your driver you would prefer to hang out. This gives you a chance to learn about the animal too. To me it is more interesting—and yields better pictures—to spend a lot of time with a few subjects than a little time with many.

If you are hiking, you probably don't want to be carrying a bunch of heavy equipment, so you may be without a long telephoto and tripod. A good way to get more photographic reach without the weight is to carry a teleconverter or extender that increases the focal length of your lenses by a factor of either 1.4 or 2, depending on the model. Remember, though, that there's no such thing as a free lunch: You lose one stop with a 1.4x, and two with a 2x. This means that the lens you have with a maximum aperture of f/2.8 will become one with either f/4 or f/5.6, and you may not be able to get a shutter speed fast enough for what you want. You also lose image quality because the light has to pass through that much more glass. Cheap teleconverters are worse than none. Expensive ones are quite good, but even they have some effect on image quality. Not all zoom lenses work well with teleconverters, so check your owner's manual to find out about yours.

Keep your camera and a longish telephoto zoom (say 80-200mm) ready so you can shoot quickly if you happen upon something interesting. Try to make as little noise as possible—don't talk, try not to step on dry twigs, etc. If the animals hear you coming, they will disappear. Wear clothing that is not too bright, and don't wear cologne or perfume. Before you set off, talk to rangers or other park employees to get an idea of what you might see where, and times of day the animals are most likely to be present. If it's a water hole, salt lick, or some other place animals visit regularly, try to get there beforehand, take up a concealed position, and wait.

Always look for pictures that either say something about the place the animal lives (a wide shot that shows the animal in its environment) or show some aspect of the animal—either its character or its behavior. Approach other animals as you would the human ones. What is the character of this animal, and how is it best represented?

Photographing Family Members and Friends

We often travel with people we know—taking a family vacation, for example, or bicycling around Tuscany with a group of friends. We quite naturally want to come home with pictures of them as souvenirs of the trip. Be sure to get these, but don't forget that you can also use members of your family and your friends to make your other photographs more effective.

When you are making pictures of your friends, try to strike a balance between a picture of them and a picture of the place. A friend of mine once made a close-up portrait of me in China. It wasn't a great portrait, but more important, it could have been made in my backyard—there was nothing of the place in the frame. Of course, you may want to shoot portraits, or to capture someone's expression at a particular moment, but often you are making the picture as a way of documenting your shared experience. You want to show enough of your friend to be able to recognize him—that vertical speck in the distance could be anybody. But you don't want to be so close that there's no context. If your friend is the primary subject, he has to be strong enough to draw attention and be recognizable but still keep some sense of where he is.

Show the activities you engage in and the reactions to them. If you go to a circus, make pictures of the clown, but spend some time watching your kids and document their expressions as the clown performs. At some point during most trips there will be awe, joy, exhilaration, fatigue, irritability, and almost every other emotion. These emotions are just as important a part of the trip as the things you do and see, and the two together form our memories. Photographs of trips are memories made real, and should show both what you experienced and how you felt about it.

Joel Sartore

Even when you are relaxing with family or friends, don't forget to make photographs. Notice how a wide-angle lens incorporates the sweep of the chairs and has everything from foreground to background in sharp focus.

You can use family members and friends to improve your images of sites by creatively incorporating them into the frame. The vertical speck in the distance I mentioned above isn't useful as a photograph of Uncle Henry, but can be quite useful if it gives scale to your main subject. When we see photographs of buildings, statues, cave entrances, or many other things, we need to have something in the frame to give us a sense of scale. Trees can do this in landscapes. Windows or doorways give us the scale of buildings—we know about what size these things normally are, and our brains quickly work out how big the mountain or building is. We also know what size people are, so if you are photographing something that needs scale, ask one of your friends to stand in a place you think is appropriate and incorporate her into the frame. Remember the rule of thirds: Putting your friend in the middle of the frame is usually not as effective as having her off to the side. If the person is looking at the main subject, it also gives the image an active sense of viewing that helps draw people into the frame.

Ask friends to help you when you're shooting street scenes. For example, you want to make images of a street vendor whose stand is piled high with fruit. You've asked and received permission, the light's right, but every time you raise your camera your subject freezes with self-consciousness. Ask your friend to talk with the vendor—ask where the fruit comes from, is that a particularly good area for growing it, whatever you can think of. Often the subject will get wrapped up in the conversation—everyone loves to talk about what they do—and forget about you and your camera.

Photographing Strangers

As I mentioned above with the street vendor, it's best to ask permission if you want to photograph someone, especially if you are working in close. Engage them before you pull out your camera. Learn at least how to say "hello" and "May I make a photograph" in the local language—just showing that you've made a little effort helps. Explain to them what you want to do and what it is about them that made you want to make a picture. If approached in an open and friendly manner, most people will be agreeable—many are flattered that someone has shown an interest in them and what they do. In places where there's a lot of tourism, you may run into people who are tired of being photographed—many tourists are not courteous enough to ask permission, and local people can come to feel abused and exploited. The only way to overcome this is to spend time with the people or to go to parts of the place less frequented by tourists.

In many tourist destinations, people may ask for money if you want to photograph them. Many of these places are desperately poor, and people have few ways of getting hold of cash. The money they ask for is usually not very much to us, but may represent quite a lot to them. How you deal

You can use either friends or strangers to lend scale to your images. A figure like the one in the red shirt also gives an active sense of "viewing" to the image.

with these situations is up to you, but remember that every time you buy a postcard, you are happy to spend money for a picture somebody else took. Why not spend a little on your own?

If you are staying in a place for a while, try to spend a day or two without making any pictures. This is especially true in villages and small towns but applies equally to cities—a certain part of the market, say, or a particular café. Spending time will give you a chance to get to know the place, to figure out what you want to photograph, and perhaps get to know a few people. It will also give the local people a chance to see you as not simply another quick-hit tourist. In places where people are not familiar with photography or have some sort of religious or cultural hesitations about it, time spent with people beforehand can greatly improve your chances of success. Don't press too hard if people are reluctant to be photographed. People are more important than pictures of them, and there are always more images down the road. Remember that you are a guest and an ambassador of your own country and culture. It's much nicer to spread goodwill than bad will.

You cannot always ask permission, of course. If you are shooting a street scene or a wide shot of a market, you can't run up to everyone and ask if it's OK. In general, people do not mind this sort of photography—it's only when they're singled out that they get uncomfortable. But not always. Be sensitive to the scene in your viewfinder. If people are getting nervous, ask permission or move on.

Make use of people to give your images life and scale. If the facade of a particular building appeals to you, the picture may be that much better if you show people walking in front of it. They will give it scale and also let viewers know what sorts of people live there, how they dress, and the like. An outdoor café may be more interesting crowded with people than empty.

Michael Melford

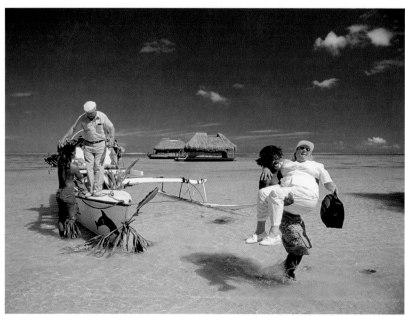

Jodi Cobb

Humor can be an important part of travel photography. Don't just look ahead at the site—look back at your fellow travelers too.

The most important thing to remember when photographing strangers is manners. Think how you would feel if a stranger stood in the doorway of your office or apartment and started making pictures of you without asking. You'd think them rude, at the least. It's the Golden Rule. If you are friendly and open, most people you encounter will be too.

Amusement Parks, Zoos, Etc.

Most amusement parks are about fun. Usually, we want our photographs of them to be amusing too—bright and cheery. Take a ride on the Ferris wheel and get a wide shot of the whole place. On a ride that's about speed and thrills, show the motion. If you're on the ride, you and your camera are moving at the same speed. A slow shutter speed will keep your fellow passengers fairly sharp but blur the background. If you are on the ground watching it whiz past, pan or blur.

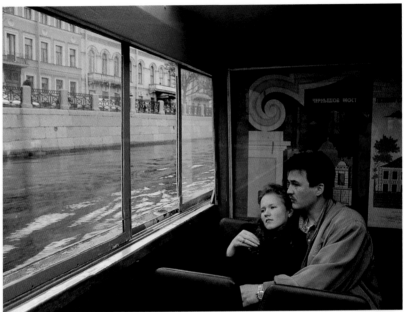

Sisse Brimberg

Photograph the rides at dusk when the lights are on. Use a tripod and slow shutter speed to get the whirl of the Ferris wheel or merry-go-round. Use the lights of the game stands and fill flash to show people at play. Use a telephoto to show the delight and fear on kids' faces. And don't forget the waiting in lines, the exhausted kids at the end of the day.

There are two basic types of photographs in zoos and wildlife parks: close-ups that concentrate on the animals, ignore the surroundings, and could pass for portraits of them anywhere, and shots that say "zoo" by including the crowds and enclosures or bars.

For portraits, you'll need a fairly long telephoto lens (at least 300mm in most cases) and a tripod. If there is an unwanted element in the frame you just can't get rid of, use shallow depth of field to minimize it. Don't be satisfied with a simple head shot. Hang around and wait for the animals to do something. The tiger cubs might be napping when you arrive, but at some point they will begin romping around.

If you are unobtrusive, you can often capture moments between people without interfering. Always be on the lookout for images, and always have your camera ready; if you have to fumble around, the moment may be gone.

Animals have personality both as species and as individuals within that species. Ask yourself, "What is this animal about? How can I capture that?"

If you want to say "zoo," look for unusual angles or details. Is it a fairly good zoo that gives the animals lots of space, or an old-fashioned menagerie?

Amusement parks offer great varieties of photographic possibilities like this Ferris wheel in Minnesota. The evening sky was dark enough to allow the ride's lights to stand out, and the tilted camera gives a dynamic angle.

Gail Mooney

Find a place where you can get the animals' point of view of the crowd staring at them. Let your images express your feelings.

Wherever you go, think about what the place represents. Why did you want to go there? Then look for the visual elements that reflect that.

MOUNTAIN CLIMBING and rock climbing, white-water rafting, spelunking, diving, trekking in arctic, forest, desert, and plain—extreme travel has become more and more popular in recent years. Besides the obvious physical challenges, each type of extreme travel presents its own photographic and gear conundrums. You want good photographs, but in most cases you don't want to carry much gear—you're rightly concerned about surviving, with carrying enough food and equipment to be able to eat, sleep warmly, and surmount your obstacle. Think carefully about what photographic gear you will actually need to get your pictures, and what you can do without.

Some of the activities require special equipment. You will need an underwater camera or an underwater housing if you're diving, and some way to protect your gear from water if you are rafting. If you are climbing or trekking, you might want to look into one of the backpacks made for camera equipment, especially if you can divvy up the other stuff with partners. Think about the environment you will be working in and refer to the camera care items we discussed earlier in this book. There's nothing worse than carrying around something that doesn't work. And remember to take enough film, digital cards, and batteries; there won't be any stores.

If you are caving or want to make pictures where or when it's dark and you haven't brought lights, you can use a technique called painting. Set the camera on a tripod or other camera support,

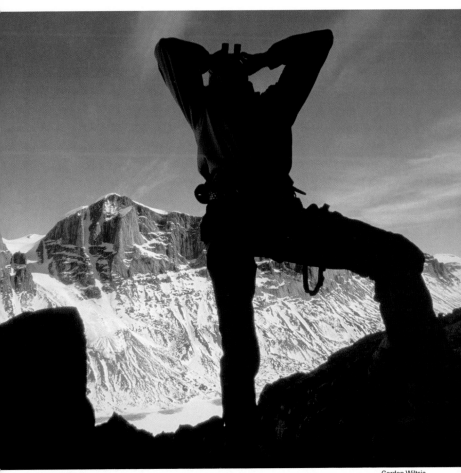

Gordon Wiltsie

frame and focus the image as best you can, then open the shutter in the bulb position so that it will stay open until you close it. Run around the scene with a flashlight or with your electronic flash and literally paint the scene with light. If you're using a flashlight, you need to keep yourself moving so your silhouette doesn't show up, and you need to keep the light beam moving so that it doesn't over-expose one area. With a flash unit, make sure you don't stand between the light and the camera (unless you want your silhouette) and try not to

The silhouetted figure gazing up creates a strong graphic and immediately tells us that the mountains keep going up. Notice the use of the rule of thirds and the great depth of field that allow us to get a feeling for the environment.

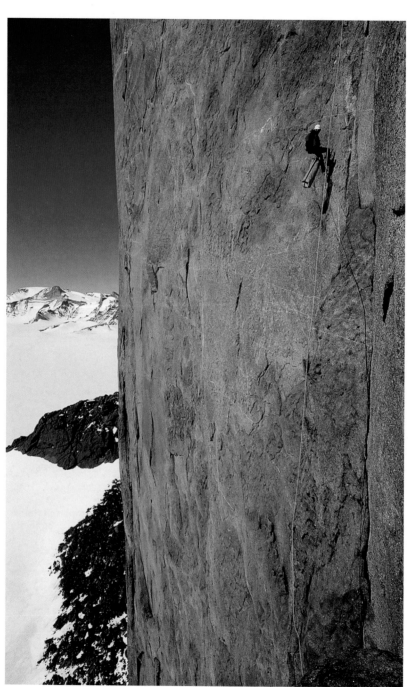

Gordon Wiltsie

fire it at the same spot more than once. Make several exposures, as it's hard to tell exactly how they will turn out. If you think you will find yourself in a situation like this, practice at home either outside at night or in a dark room.

Don't forget about other lights you may have brought along but that you may not normally think of for photography. Mantle lamps that use pressurized gas or kerosene throw off a lot of light—certainly enough to illuminate people sitting around a table inside a tent. If you have a car, use the headlights. If you have a white sheet or pillowcase, use it as a reflector.

Above all, don't risk injury for the sake of a photograph; there's no picture that's worth your life. Just as you would when eyeing the next handhold or studying the rapids, keep safety first.

Photographing inside caves like this one in New Mexico requires lots of light. Don't forget that you can use lanterns and the lights on the cavers' heads. The small figure in the picture at left immediately communicates the cliff's size.

Michael Nichols

WHEN YOU GET HOME, there are a few things you should do to make sure that your equipment is ready for the next trip and that your images are safe. None of these take much time, and doing them will save you a lot of time in the future.

Taking Care of Your Gear

Clean the lens surfaces with a camel-hair brush and with lens-cleaning fluid and paper if needed. Wipe the camera and lens bodies with a soft cotton cloth to rid them of dust and grime. Open the camera back and lens hole, and, with a can of pressurized air, blow dust out. If you will not be using the camera for a while, remove the batteries—we all know how they corrode. Remove them from your flash and anything else that uses batteries too.

If you dropped a lens, can hear sand grate when you focus or zoom, or suspect any other problem, have the piece cleaned. A grain of sand wedged in a focusing ring can cause serious problems, and the longer it stays there and eats away, the worse the problem. Clean your camera bag and cases, wipe the legs of your tripod—basically clean everything and store it all where it is not exposed to too much dust.

Taking Care of Your Film

Have your film processed as soon as you can upon returning home. If you've shot negative film, be sure to mark the negative holders and

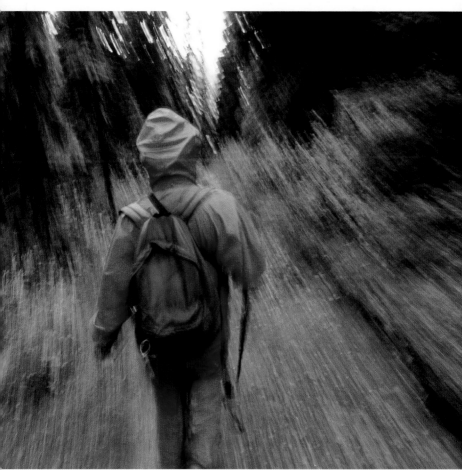

Michael Melford

corresponding prints so you know which pictures came from which roll. Store the negatives in a dry place without great temperature variations. If you've shot transparency film, number the boxes of slides and go through them one by one. Any slides you remove from a box should be marked with the roll number in case you want to go back to look for similar frames. Keep the boxes of unse-lected slides in a cool, dry place. Keep your selects in archival plastic slide sleeves or in bundles in archival storage boxes.

Keeping pace with the brightly dressed woman, a slow shutter speed kept her fairly sharp but blurred the green around her.

Sort transparencies by subject. The quickest way is with a light table and a loupe.

Because much sending of pictures is done electronically these days, it's a good idea to have scans of your best images. If you have a film scanner, you can do this yourself and then burn them onto a CD or DVD. If you don't have a film scanner, take them to a lab that can scan and burn them. If you are not familiar with your local labs, try to find out which has a reputation for making good scans—they can vary widely. Once you have CDs or DVDs with your best images, make copies of them and keep them in a location different from where you store the originals.

You can now make prints, send images to friends, post them on a Web site, or put together an electronic portfolio.

Burning CDs or DVDs From Your Digital Files

Traveling with a digital camera means coming home with flash cards or other media full of images. If you've taken along a laptop or other portable storage device, you've probably been dumping the photographs into it as you've gone along (or you should have been). Now you need to get them onto a more permanent medium.

The first thing to do is burn CDs or DVDs of your images. Most personal computers come with CD burners, and some come with DVD burners. Make folders for different parts of the trip, put them together in a larger folder that nears the capacity of your blank CD or DVD, and burn away.

Once you have your CDs or DVDs, you should right away make contact sheets so you know what's on what disk. Many popular image manipulation

Robert Caputo (both)

programs have this capacity (Photoshop has it in the File menu under Automate). If your software allows it, have it print the image ID number under the thumbnail so you can easily locate images.

As you set up your software to make the contact sheets, think carefully about what dimensions and resolution you want the images to be. You may not want to be compelled to pore over them with a magnifying glass every time you want to locate a frame. Print the thumbnails large enough to be seen easily. They do not have to be high resolution, but they should be high enough to give you the detail you need to judge an image's quality. The contact sheets do not have to fit in the 5x5-inch CD or DVD cover—label the CDs or DVDs and the corresponding contact sheets and keep the sheets in a folder or binder.

Then it's simply a matter of importing some or all of your photographs into image management software like iPhoto, Extensis, PhotoStation, or one of the others. You can edit, manipulate, print, or send images to friends, create a portfolio, or do just about anything you want with them.

Once you've scanned your images and burned them onto a CD or DVD, use a computer program to edit.

FOLLOWING PAGES: Doorways to old worlds and new: The photographer has used colors, textures, and internal frames to give us an evocative image of an abandoned house on the plains.

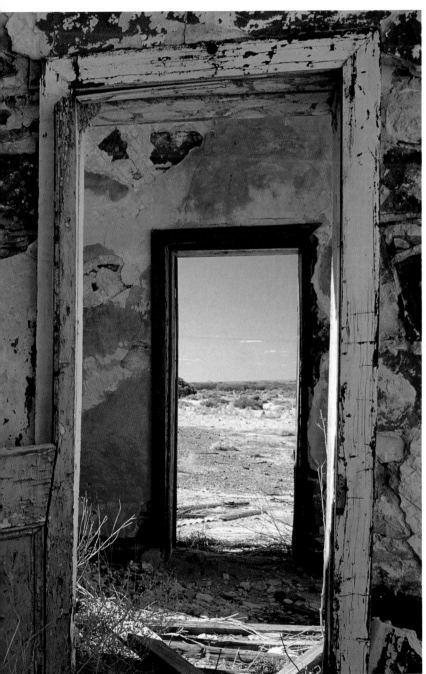

Medford Taylor

CHECKLIST

Camera Bag Essentials
• camera bag lined with foam-rubber compartments
• camera body with body cap and neck strap
• favorite lenses with lens caps
• lens hoods
• film and/or media cards for digital cameras
• air blower brush
• lens cleaner solution and lens tissue wipes
• electronic flash
• extra batteries
• remote release
• notebook and permanent marker

Options
• handheld exposure meter
• filters such as UV haze, skylight 1A, polarizing, neutral density, graded neutral density, light amber, light blue
• tripod, monopod, and/or beanbags
• gaffer's tape
• plastic bag or sheet to protect equipment in wet weather
• soft absorbent towel or chamois
• silica gel for humid weather
• large umbrella
• cooler for hot weather
• extra camera body
• extra electronic flash
• extra handheld exposure meter
• equipment manuals
• selenium cell exposure meter that operates in cold weather
• self-stick labels to identify film
• sunglasses
• head and wrist sweat bands
• camouflage clothing for shooting landscapes with animals
• 18% gray card
• resealable plastic bags for storing film
• customized diopter to match your eyeglass prescription
• reflectors
• slave units for electronic flash

Tool Kit
• film changing bag
• film leader retriever
• Swiss Army knife
• filter wrench
• small socket wrenches
• jeweler's screwdrivers
• tweezers
• needle-nosed pliers to loosen jammed tripod joints

Safety
• flashlight
• compass
• whistle
• water
• snacks
• medical first-aid kit
• reflective tape for clothing during nighttime shooting

WEB SITES

The Web is an invaluable resource for all sorts of photography and for research. Most photographic (and other) magazines have Web sites, as do most photographic agencies and individual photographers. You can join discussion groups, read articles about and by photographers, and look at an infinite number of images. Before you travel, visit the Web sites of the country or site of your destination, check the weather there, get tips on where to go and what to see, find out if there are any festivals or other events. Use a search engine to find sites by photographer's, country's, or locations' name or by keyword.

The following is a partial list of Web sites to get you started. There are too many countries and other travel destinations to list them all here. Remember that sites can change or even disappear. There is no substitute for surfing.

AOL Photography Forums
 (on AOL only; keyword: Photography)
American Society of Media Photographers
 http://www.asmp.org

Apogee On-Line Photo magazine
 http://www.apogeephoto.com
Camera Arts magazine
 http://www.cameraarts.com
E-Digital Photo magazine
 http://www.edigitalphoto.com
Ira Block
 http://www.irablock.com
Jim Richardson
 http://www.jimrichardson.com
National Geographic Society
 http://www.nationalgeographic.com
Outdoor Photographer magazine
 http://www.outdoorphotographer.com
PC Photo magazine
 http://www.pcphotomag.com
Photo District News magazine
 http://www.pdnonline-pix.com
Photo Electronic Imaging magazine
 http://www.peimag.com
PHOTO LIFE magazine (Canada)
 http://www.photolife.com
Photo Travel Guides Online
 http://phototravel.com/guides.htm
Photograph America newsletter
 http://www.photographamerica.com
PhotoSecret's Travel Guides for
 Travel Photography
 http://www.photosecrets.com
Professional Photographers of
 America (PPA)
 http://www.ppa-world.org
Robert Caputo
 http://www.robertcaputo.com
Sarah Leen
 http://www.sarahleen.com
Shaw Guides to Photo Tours and
 Workshops
 http://www.shawguides.com
Shutterbug magazine
 http://www.shutterbug.net

PHOTOGRAPHY MAGAZINES AND BOOKS

Magazines

There is an abundance of magazines about both the art and technique of photography. Most have Web sites— a Google of "photography magazine" turns up over 40,000 sites. Visit Web sites of ones that strike your fancy to see if you want to subscribe. Alternatively, go to a good newsstand and browse. While you are there, look through some of the plethora of travel magazines for information and tips about your destination and to see how other photographers have treated travel subjects. Pictures of people appear in just about every magazine published, so look at a wide range of them to see how photographers have treated people photography. I strongly recommend going to a library and looking at old issues of *Life* and *Look*.

Books

As with photography magazines, the number of photography books is vast— far too big to list here. They fall into two categories: books *about* photography (techniques, gear, composition, and the like) and books *of* photography. Visit online or brick-and-mortar bookstores to browse through both categories. Many online sites feature reviews and commentary that can help you decide which books of photographic technique might be best for you. The same is true for travel guidebooks, of which there are many— *Fodor's, Rough Guides,* and *Lonely Planet* just to name a few.

To really study books of photographs, it's best to view them in print. Go to bookstores and libraries to pore over the work of photographers who make the sort of images you are interested in and books about your intended destination. When you find books that really excite you, buy them and take them home so you can turn to them for inspiration.

Boldface indicates illustrations.

A

Accessories 41-44, **47**
Amusement park photography 142-144, **144**
Angles 63-65
Aperture 85
 lenses and 38-39
 shutter speed and 67-69, 73, 74

B

Batteries 42, 44, 75
Block, Ira 26-31
Blurring **70**, 71, 73-74, 89
Building photography 128-132, **129**
Burning *see* CD/DVD burning

C

Cable release 41-42
Cameras 34-36; *see also* Digital cameras; SLR-type cameras; Underwater cameras
 bags 45, 46-47, **47**, 74
 bodies **34**, 34-36, **35**
 cases **45**, 45-46
 cleaning 44, 150
 protecting 49, 74-75, 92
 range-finder 35
 repairing 44
CD/DVD burning 152-153
Color
 digital camera 69
 flash 69
 indoor 71, 132
 lighting and 69-71, 91, 132
 rendition **69**, 69-71
Composition **50**, 50-65, **53**, **54**
 angles 62-65
 depth of field 57-61, **61**
 foreground elements 57-61, **61**
 frames **50**, 62-65, **65**
 graphic elements 62-65, **64**
 leading lines **56**, 57-61, 124
 patterns 62-63
 rule of thirds 53-56, **58**, 138
Contact sheets 153
Customs/traditions 15-17, 83, 121

D

Depth of field 57-61, **61**
 digital camera 61
 lenses and 60, 66
 shutter speed and 73, 74
Digital cameras 127
 color and 69
 depth of field and 61
 digital file processing from 152-153, **153**
 lenses 38
 second tier **35**
 SLR-type 34, 35
Digital cards 35, 42, 44, 127, 152
 ISO rating 67-69
 processing 152-153, **153**
 protecting 74

E

Equipment 32-49, **33**; *see also* Batteries; Cameras; Film; Flashes; Lenses
 accessories 41-44
 bags 45, 46-47, **47**, 74
 cable release 42
 cases **45**, 45-46
 cold and 74
 extreme travel 146
 humidity and 74
 protecting 45-48, 74-75, **76**, 92
 safety 49
 taking care of 150
 traveling with 31, 32-34, 46-48
Exposure
 bracketing 109-110, 124
 landscape 124
 lighting and 114
 night 110, **112**
 snow 93-94
Extreme travel photography **146**, 146-153, 147, **148**, **149**

F

Film
 inside photography 132
 ISO-type 42-44, 67-69
 processing 150-152
 protecting 74-75
 shipping 48
 traveling with 31, 47-48

 tungsten 132
 type 42-44
Filters 42
Flashes 42, 44, **44**
 color and 69
 extreme travel 147
 fill 88
 fog/mist and 94-95
 inside 132
 sunrise/set 115
 tilt-head **44**
Floodlights 90
Fog photography 94-95, **102**
Foreground elements 57-61, **61**
Frames **50**, 62-65, **65**
 internal 65, **65**

G

Graphic elements **62**, 62-65, **64**

I

Image processing 150-153
 CD/DVD burning 152-153
 scanning 152-153
Inside photography 71, 132-133, **133**
ISO rating 42-44, 67-69, 85-86

K

Keystoning 128

L

Landscape photography 82-83, 105, **105**, **122**, 122-124
Laptops 44, 152
Leading lines **56**, 57-61, 124
Leen, Sarah 78-83
Lenses 37-41; *see also* Macro lenses; Telephoto lenses; Wide-angle lenses; Zoom lenses
 amusement park 143
 aperture and 38-39
 choosing 66
 cleaning 36, 44, 150
 depth of field and 60-61
 digital cameras 38
 fog and 94
 lighting and 114
 moisture and 92
 portrait **38**, 39, **39**
 protecting 92

shutter speed and 71
SLR-type camera 37
sports 40
sun and 114
wildlife 40, 135, 136, 143
Lighting; see also Flashes;
 Painting; Reflectors
 ambient 109
 available 84-90, 85-88
 bracketing exposures and
 109, 110
 color and 69-71, 91
 dawn 108-109, 111-114
 digital camera 90
 dusk 108-109, 110
 exposure and 109, 110, 114
 extreme travel 146-148
 faint 109-110
 indoor 132-133, 133
 landscape 105
 lenses 114
 location 84-91, 84-91
 mood 102-103
 night 31, 108-110, 112
 odd 90-91, 91
 shutter speed and 34, 109
 sunrise/set 111-115, 115
 time of day and 104-114
Location
 scouting 104-106
 sense of 8-16, 8-25, 20-25

M

Macro lenses 42, 42, 43
Monument photography 128-
 132, 129, 130
Mood
 conveying 101-103
 light and 102-103
 weather and 95, 101-103

N

Negatives 151-153
Notes 17-19
 first impression 17
 research 17
 scouting 106

P

Painting 146-147
Panning 72-73
People photography 39, 83,
 101
 family 137-138

monuments and 129, 130
strangers 139-142
street shooting and 127

R

Reflectors 90
Research 8-14, 81, 120-121
 Internet 12, 81
 notes 18-19
Richardson, Jim 116-121
Rule of thirds 53, 53-57, 138

S

Scouting 31, 104-108
Seasonal photography 92-103,
 95, 100
Self-timer 71, 109
Shutter speed 70, 71-74, 72
 aperture and 67-69, 73, 74
 blurring and 73-74
 cable release and 41-42
 depth of field and 73, 74
 fast 19, 20
 lenses and 71
 light and 34, 109
 slow 89, 112, 151
 weather and 92-93
Silica gel 44, 75
SLR-type cameras 34, 34-35,
 37-38, 61
 digital 34, 35
 lenses 37
Software, image management
 152-153
Sports photography 40
Street shooting 125-128, 139
Subjects 82, 122-144
 amusement park 142-144,
 144
 city and town 124-128, 125
 composition and 53-59
 family and friends 137-138
 inside 132-133
 landscapes 82-83, 105, 105,
 122, 122-124
 monument and building
 128-132
 strangers 139-142
 wildlife 133-136
 zoo 142-144

T

Telephoto lenses 40, 40, 40-41,
 41, 42, 43, 60, 66, 67, 96, 143

depth of field and 60, 66
Themes 19, 22-24, 81
Transparencies 151, 152
Tripods 31, 41-42, 71

U

Underwater cameras 34, 146

V

Vantage points 31, 124

W

Weather 92-103, 106
 fog 94, 102
 inclement 92-95, 93
 mood and 95, 101-103
 shutter speed and 92-93
 snow 93, 93-94
Wide-angle lenses 31, 36, 37,
 37, 60, 64, 66
 depth of field and 60, 66
Wildlife photography 133-136
 lens 40, 67, 135, 136, 143
 zoo 142-144

Z

Zoo photography 142-144
Zoom lenses 37, 39, 39-40, 66,
 136

National Geographic
Photography Field Guide
Travel

Robert Caputo

Published by the National Geographic Society

John M. Fahey, Jr., *President and Chief Executive Officer*

Gilbert M. Grosvenor, *Chairman of the Board*

Nina D. Hoffman, *Executive Vice President*

Prepared by the Book Division

Kevin Mulroy, *Vice President and Editor-in-Chief*

Charles Kogod, *Illustrations Director*

Marianne R. Koszorus, *Design Director*

Staff for this Book

Charles Kogod, *Editor*

Judy Klein, *Text Editor*

Cinda Rose, *Art Director*

Kay Hankins, *Designer*

Bob Shell, *Technical Consultant*

R. Gary Colbert, *Production Director*

Lewis Bassford, *Production Project Manager*

Meredith C. Wilcox, *Illustrations Coordinator*

Robert Swanson, *Indexer*

Manufacturing and Quality Control

Christopher A. Liedel, *Chief Financial Officer*

Phillip L. Schlosser, *Financial Analyst*

John T. Dunn, *Technical Director*

Alan Kerr, *Manager*

Library of Congress Cataloging-in-Publication Data

Caputo, Robert, 1949–

National Geographic photography field guide: travel : secrets to making great pictures / Robert Caputo.

p. cm.

includes index

ISBN 0-7922-9505-6

1. Travel photography—Handbooks, manuals, etc. I. National Geographic Society (U.S.)

II. Title.

TR790.C37 2005

778.9'991—dc22 2004059720

One of the world's largest nonprofit scientific and educational organizations, the National Geographic Society was founded in 1888 "for the increase and diffusion of geographic knowledge." Fulfilling this mission, the Society educates and inspires millions every day through its magazines, books, television programs, videos, maps and atlases, research grants, the National Geographic Bee, teacher workshops, and innovative classroom materials.

The Society is supported through membership dues, charitable gifts, and income from the sale of its educational products. This support is vital to National Geographic's mission to increase global understanding and promote conservation of our planet through exploration, research, and education.

For more information, please call 1-800-NGS LINE (647-5463) or write to the following address:

National Geographic Society
1145 17th Street N.W.
Washington, D.C. 20036-4688 U.S.A.

Visit the Society's Web site at www.nationalgeographic.com.

FRONT COVER: A bright yellow umbrella sits like the sun over the pale blue waters of a beach in Thailand. Always look for unusual angles to lend more interest to your photographs.

Jodi Cobb